An Armchair Guide to Tattoos, Including the History of Tattooing, Many Different Types of Tattoos and Biographies of Tattoo Artists Including Kat Von D and Ami James and More

Stefanie Allen

The role of the book within our culture is changing. The change is brought on by new ways to acquire & use content, the rapid dissemination of information and real-time peer collaboration on a global scale. Despite these changes one thing is clear--"the book" in it's traditional form continues to play an important role in learning and communication. The book you are holding in your hands utilizes the unique characteristics of the Internet -- relying on web infrastructure and collaborative tools to share and use resources in keeping with the characteristics of the medium (user-created, defying control, etc.)--while maintaining all the convenience and utility of a real book.

Contents

Articles

Tattoo Medical Issues

References

Introduction

Tattoo

A **tattoo** is a marking made by inserting indelible ink into the dermis layer of the skin to change the pigment for decorative or other reasons. Tattoos on humans are a type of decorative body modification, while tattoos on animals are most commonly used for identification or branding. The term "tattoo" or from Samoa, "Tatau" is first referred to by Joseph Banks, the naturalist aboard Cook's ship the "Endeavour" in 1769 where he mentions it in his journal. To paraphrase. he states, "I shall now mention the way they mark themselves indelibly, each of them is so marked by their humor or disposition".

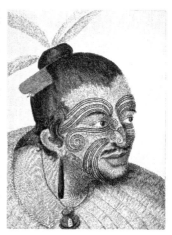

A Māori Chief with tattoos (moko) seen by Cook and his crew

Tattooing has been practiced for centuries worldwide. The Ainu, the indigenous people of Japan, traditionally wore facial tattoos. Today one can find Berbers of Tamazgha (North Africa), Māori of New Zealand, Arabic people in East-Turkey and Atayal of Taiwan with facial tattoos. Tattooing was widespread among Polynesian peoples and among certain tribal groups in the Taiwan, Philippines, Borneo, Mentawai Islands, Africa, North America, South America, Mesoamerica, Europe, Japan, Cambodia, New Zealand and Micronesia. Despite some taboos surrounding tattooing, the art continues to be popular in many parts of the world.

Etymology

The OED gives the etymology of tattoo as "In 18th c. tattaow, tattow. From Polynesian tatau. In Tahitian, tatu." The word tatau was introduced as a loan word into English, the pronunciation being changed to conform to English phonology as "tattoo". Sailors on later voyages introduced both the word and reintroduced the concept of tattooing to Europe.

Tattoo enthusiasts may refer to tattoos as "Ink", "Tats", "Art", "Pieces", or "Work"; and to the tattooists as "Artists". The latter usage is gaining greater support, with mainstream art galleries holding exhibitions of both conventional and custom tattoo designs. Copyrighted tattoo designs that are mass-produced and sent to tattoo artists are known as flash, a notable instance of industrial design. Flash sheets are prominently displayed in many tattoo parlors for the purpose of providing both inspiration and ready-made tattoo images to customers.

The Japanese word *irezumi* means "insertion of ink" and can mean tattoos using *tebori*, the traditional Japanese hand method, a Western-style machine, or for that matter, any method of tattooing using insertion of ink. The most common word used for traditional Japanese tattoo designs is *Horimono*. Japanese may use the word "tattoo" to mean non-Japanese styles of tattooing.

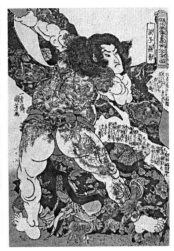

Japanese painting of Yan Qing, who is famous for his tattoo in Chinese Classical Masterpiece "The Outlaws of the Marsh". (c.1800s)

In Taiwan, facial tattoos of the Atayal tribe are named "Badasun"; they are used to demonstrate that an adult man can protect his homeland, and that an adult woman is qualified to weave cloth and perform housekeeping.[*citation needed*]

The anthropologist Ling Roth in 1900 described four methods of skin marking and suggested they be differentiated under the names of tatu, moko, cicatrix, and keloid.

History

Main article: History of tattooing

Tattooing has been a Eurasian practice at least since around Neolithic times. Ötzi the Iceman, dating from the fourth to fifth millennium BC, was found in the Ötz valley in the Alps and had approximately 57 carbon tattoos consisting of simple dots and lines on his lower spine, behind his left knee, and on his right ankle. These tattoos were thought to be a form of healing because of their placement which resembles acupuncture. [19] Other mummies bearing tattoos and dating from the end of the second millennium BC have been discovered, such as the Mummy of Amunet from Ancient Egypt and the mummies at Pazyryk on the Ukok Plateau.

Pre-Christian Germanic, Celtic and other central and northern European tribes were often heavily tattooed, according to surviving accounts. The Picts were famously tattooed (or scarified) with elaborate dark blue woad (or possibly copper for the blue tone) designs. Julius Caesar described these tattoos in Book V of his *Gallic Wars* (54 BC).

Tattooing in Japan is thought to go back to the Paleolithic era, some ten thousand years ago.[citation needed] Various other cultures have had their own tattoo traditions, ranging from rubbing cuts and other wounds with ashes, to hand-pricking the skin to insert dyes.

Tattooing in the Western world today has its origins in Polynesia, and in the discovery of *tatau* by eighteenth century explorers. The Polynesian practice became popular among European sailors, before spreading to Western societies generally.

Purposes

Decorative and spiritual uses

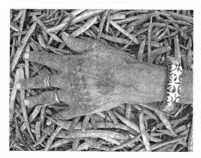

Tattooing is a tradition among many of the indigenous peoples around the world.

Tattoos have served as rites of passage, marks of status and rank, symbols of religious and spiritual devotion, decorations for bravery, sexual lures and marks of fertility, pledges of love, punishment, amulets and talismans, protection, and as the marks of outcasts, slaves and convicts. The symbolism and impact of tattoos varies in different places and cultures. Tattoos may show how a person feels about a relative (commonly mother/father or daughter/son) or about an unrelated person.

Today, people choose to be tattooed for cosmetic, sentimental/memorial, religious, and magical reasons, and to symbolize their belonging to or identification with particular groups, including criminal gangs (see criminal tattoos) but also a particular ethnic group or law-abiding subculture. Some Māori still choose to wear intricate moko on their faces. In Laos, Cambodia, and Thailand, the yantra tattoo is used for protection against evil and to increase luck. In the Philippines certain tribal groups believe that tattoos have magical

A memorial tattoo of a deceased loved one's initials

qualities, and help to protect their bearers. Most traditional tattooing in the Philippines is related to the bearer's accomplishments in life or rank in the tribe. Among Catholic Croats in Bosnia and Herzegovina, tattoos with Christian symbols would be inked on to protect themselves from the Muslim Turks.

Extensive decorative tattooing is common among members of traditional freak shows and by performance artists who follow in their tradition.

Identification

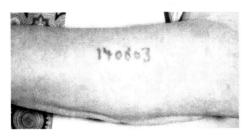

A Nazi concentration camp identification tattoo

People have also been forcibly tattooed. A well known example is the identification system for inmates in Nazi concentration camps during the Holocaust. Tattoos have also been used for identification in other ways. For example, in the period of early contact between the Māori and Europeans, Māori chiefs sometimes drew their moko (facial tattoo) on documents in place of a signature. Tattoos are sometimes used by forensic pathologists to help them identify burned, putrefied, or mutilated bodies. Tattoo pigment is buried deep enough in the skin that even severe burns are not likely to destroy a tattoo.[citation needed] For many centuries seafarers have undergone tattooing for the purpose of enabling identification after drowning. In this way recovered bodies of such drowned persons could be connected with their family members or friends before burial. Therefore tattooists often worked in ports where potential customers were numerous. The traditional custom continues today in the Royal Navy (Great Britain) and in many others.[citation needed]

Tattoos are also placed on animals, though very rarely for decorative reasons. Pets, show animals, thoroughbred horses and livestock are sometimes tattooed with identification and other marks. Pet dogs and cats are often tattooed with a serial number (usually in the ear, or on the inner thigh) via which their owners can be identified. Also, animals are occasionally tattooed to prevent sunburn (on the nose, for example). Such tattoos are often performed by a veterinarian and in most cases the animals are anesthetized during the process. Branding is used for similar reasons and is often performed without anesthesia, but is different from tattooing as no ink or dye is inserted during the process.

Mark of a deserter from the British Army. Tattoo on skin and equipment. Displayed at Army Medical Services Museum.

Cosmetic

Main article: Permanent makeup

When used as a form of cosmetics, tattooing includes permanent makeup and hiding or neutralizing skin discolorations. Permanent makeup is the use of tattoos to enhance eyebrows, lips (liner and/or lipstick), eyes (liner), and even moles, usually with natural colors as the designs are intended to resemble makeup.

Medical

Main article: Medical tattoo

Medical tattoos are used to ensure instruments are properly located for repeated application of radiotherapy and for the areola in some forms of breast reconstruction. Tattooing has also been used to convey medical information about the wearer (e.g. blood group). Tattoos are used in skin tones to cover vitaligo, skin pigmentation disorder.

Fraternal/Social

Members of college fraternities and sororities often voluntarily elect to have their fraternity or sorority letters tattooed on their bodies.

Prevalence

Tattoos have experienced a resurgence in popularity in many parts of the world, particularly in North and South America, Japan, and Europe. The growth in tattoo culture has seen an influx of new artists into the industry, many of whom have technical and fine arts training. Coupled with advancements in tattoo pigments and the ongoing refinement of the equipment used for tattooing, this has led to an improvement in the quality of tattoos being produced.

During the first decade of the 21st century, the presence of tattoos became evident within pop culture, inspiring television shows such as A&E's *Inked* and TLC's *Miami Ink* and *LA Ink*. The decoration of blues singer Janis Joplin with a wristlet and a small heart on her left breast, by the San Francisco tattoo artist Lyle Tuttle, has been called a seminal moment in the popular acceptance of tattoos as art.

Formal interest in the art of the tattoo has become prominent in the 1990s through the beginning of the 21st century. Contemporary art exhibitions and visual art institutions have featured tattoos as art through such means as displaying tattoo flash, examining the works of tattoo artists, or otherwise incorporating examples of body art into mainstream exhibits. One such 2009 Chicago exhibition *Freaks & Flash* featured both examples of historic body art as well as the tattoo artists which produced it.

In many traditional cultures tattooing has also enjoyed a resurgence, partially in deference to cultural heritage. Historically, a decline in traditional tribal tattooing in Europe occurred with the spread of Christianity. However, some Christian groups, such as the Knights of St. John of Malta, sported tattoos to show their allegiance. A decline often occurred in other cultures following European efforts to convert aboriginal and indigenous people to Western religious and cultural practices that held tattooing to be a "pagan" or "heathen" activity. Within some traditional indigenous cultures, tattooing takes place within the context of a rite of passage between adolescence and adulthood.

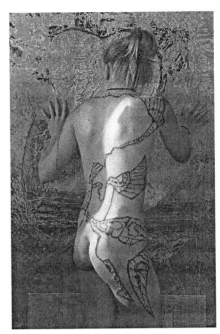

Woman with Tattoo

Many studies have been done of the tattooed population and society's view of tattoos. In June 2006 the Journal of the American Academy of Dermatology published the results of a telephone survey which took place in 2004. It found that 36% of Americans ages 18–29, 24% of those 30-40 and 15% of those 41-51 had a tattoo. In September 2006, the Pew Research Center conducted a telephone survey which found that 36% of Americans ages 18–25, 40% of those 26-40 and 10% of those 41-64 had a tattoo. In January 2008, a survey conducted online by Harris Interactive estimated that 14% of all adults in the United States have a tattoo, just slightly down from 2003, when 16% had a tattoo. The highest incidence of tattoos was found among the gay, lesbian and bisexual population (25%) and people living in the West (20%). Among age groups, 9% of those ages 18–24, 32% of those 25-29, 25% of those 30-39 and 12% of those 40-49 have tattoos, as do 8% of those 50-64. Men are just slightly more likely to have a tattoo than women (15% versus 13%)

Negative associations

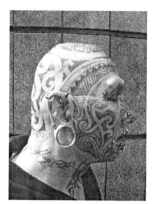

Conspicuous tattoos and other body modification can make gainful employment difficult in many fields.

In Japan, tattoos are strongly associated with organized crime organizations known as the *yakuza*, particularly full body tattoos done the traditional Japanese way (*Tebori*). Many public Japanese bathhouses (*sentō*) and gymnasiums often openly ban those bearing large or graphic tattoos in an attempt to prevent Yakuza from entering. The Government of Meiji Japan had outlawed tattoos in the 19th century, a prohibition that stood for 70 years before being repealed in 1948.

In the United States many prisoners and criminal gangs use distinctive tattoos to indicate facts about their criminal behavior, prison sentences, and organizational affiliation. A tear tattoo, for example, can be symbolic of murder, with each tear representing the death of a friend. At the same time, members of the U.S. military have an equally well established and longstanding history of tattooing to indicate military units, battles, kills, etc., an association which remains widespread among older Americans. Tattooing is also common in the British Armed Forces.

Tattooing was also used by the Nazi regime in Nazi concentration camps to tag prisoners.

Insofar as this cultural or subcultural use of tattoos predates the widespread popularity of tattoos in the general population, tattoos are still associated with criminality. Although the general acceptance of tattoos is on the rise in Western society, they still carry a heavy stigma among certain social groups. Tattoos are generally considered an important part of the culture of the Russian mafia.

The prevalence of women in the tattoo industry, along with larger numbers of women bearing tattoos, appears to be changing negative perceptions with the exception of so called "tramp-stamp", a lower back tattoo. A study of "at-risk" (as defined by school absenteeism and truancy) adolescent girls showed a positive correlation between body-modification and negative feelings towards the body and self-esteem; however, also illustrating a strong motive for body-modification as the search for "self and attempts to attain mastery and control over the body in an age of increasing alienation."

Religious perspectives

Christianity

See also: Religious Tattoos among Croatians in Bosnia and Herzegovina

There is no consistent Christian position on tattooing. The majority of Christians do not take issue with the practice, while a minority uphold the Hebrew view against tattoos (see below) based on Leviticus 19:28. Tattoos of Christian symbols are common. When on pilgrimage, some Christians get a small tattoo dating the year and a small cross. This is usually done on the forearm.

Catholic Croats of Bosnia and Herzegovina used tattooing, especially of children, for perceived protection against forced conversion to Islam during Turkish occupation of Bosnia and Herzegovina (1463-1878). This form of tattooing continued long past its original motivation, though it was forbidden during Yugoslavian communism. Tattooing was performed during spring time or during special religious celebrations such as the Feast of St. Joseph, and consisted mostly of Christian crosses on hands, fingers, forearms, and below the neck and on the chest.

Coptic Christians who live in Egypt tattoo themselves with the symbols of Coptic crosses on their right wrists.

Mormonism

Members of the Church of Jesus Christ of Latter-day Saints (often referred to as "Latter-day Saints" or "Mormons") have been advised by their church leaders to not tattoo their bodies. In the Articles of Faith of The Church of Jesus Christ of Latter-Day Saints it states that the Latter-day Saints accept the Bible to be the word of God Therefore, the church believes that the body is a sacred temple as preached in the New Testament, and that they should keep it clean, inside and out, which the church interprets as forbidding tattoos.

Islam

Tattoos are usually considered forbidden in Sunni Islam. According to the book of Sunni traditions, Sahih Bukhari, "The Prophet forbade [...] mutilation (or maiming) of bodies." Sunni Muslims believe tattooing is forbidden and a sin because it involves changing the creation of God (Surah 4 Verse 117-120), and because the Prophet cursed the one who does tattoos and the one for whom that is done. There is, however, difference of scholarly Sunni Muslim opinion as to the reason why tattoos are forbidden. The use of temporary tattoo made with henna is very common in Muslim North-Africa. The permissibility of tattoos is debated in Shi'a Islam, with some Shi'a pointing to a ruling by Ayatollah Sistani stating they are permitted.

Judaism

Tattoos are forbidden in Judaism based on the Torah (Leviticus 19:28): "You shall not make gashes in your flesh for the dead, or incise any marks on yourselves: I am the Lord." The prohibition is explained by contemporary rabbis as part of a general prohibition on body modification that does not serve a medical purpose (such as to correct a deformity). Maimonides, a leading 12th century scholar of Jewish law and thought, explains the prohibition against tattoos as a Jewish response to paganism. Since it was common practice for ancient pagan worshipers to tattoo themselves with religious iconography and names of gods, Judaism prohibited tattoos entirely in order to disassociate from other religions. In modern times, the association of tattoos with Nazi concentration camps and the Holocaust has given an additional level for revulsion to the practice of tattooing, even among many otherwise fairly secular Jews.

Procedure

Tattooing involves the placement of pigment into the skin's dermis, the layer of dermal tissue underlying the epidermis. After initial injection, pigment is dispersed throughout a homogenized damaged layer down through the epidermis and upper dermis, in both of which the presence of foreign material activates the immune system's phagocytes to engulf the pigment particles. As healing proceeds, the damaged epidermis flakes away (eliminating surface pigment) while deeper in the skin granulation tissue forms, which is later converted to connective tissue by collagen growth. This mends the upper dermis, where pigment remains trapped within fibroblasts, ultimately concentrating in a layer just below the dermis/epidermis boundary. Its presence there is stable, but in the long term (decades) the pigment tends to migrate deeper into the dermis, accounting for the degraded detail of old tattoos.

Modern tattoo machine in use: here outfitted with a 5-needle setup, but number of needles depends on size and shading desired.

Some tribal cultures traditionally created tattoos by cutting designs into the skin and rubbing the resulting wound with ink, ashes or other agents; some cultures continue this practice, which may be an adjunct to scarification. Some cultures create tattooed marks by hand-tapping the ink into the skin using sharpened sticks or animal bones (made like needles) with clay formed disks or, in modern times, needles. Traditional Japanese tattoos (*Horimono*) are still "hand-poked," that is, the ink is inserted beneath the skin using non-electrical, hand-made and hand held tools with needles of sharpened bamboo or steel. This method is known as *tebori*.

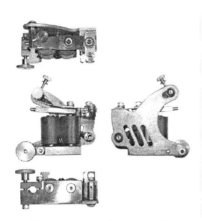
Traditional two coil tattoo machine

The most common method of tattooing in modern times is the electric tattoo machine, which inserts ink into the skin via a group of needles that are soldered onto a bar, which is attached to an oscillating unit. The unit rapidly and repeatedly drives the needles in and out of the skin, usually 80 to 150 times a second. This modern procedure is ordinarily sanitary. The needles are single-use needles that come packaged individually. The tattoo artist must wash not only his or her hands, but they must also wash the area that will be tattooed. Gloves must be worn at all times and the wound must be wiped frequently with a wet disposable towel of some kind.

Prices for this service vary widely globally and locally, depending on the complexity of the tattoo, the skill and expertise of the artist, the attitude of the customer, the costs of running a business, the economics of supply and demand, etc. The time it takes to get a tattoo is in proportion with its size and complexity. A small one of simple design might take fifteen minutes, whereas an elaborate sleeve tattoo or back piece requires multiple sessions of several hours each.

The modern electric tattoo machine is far removed from the machine invented by Samuel O'Reilly in 1891. O'Reilly's machine was based on the rotary technology of the electric engraving device invented by Thomas Edison. Modern tattoo machines use electromagnetic coils. The first coil machine was patented by Thomas Riley in London, 1891 using a single coil. The first twin coil machine, the predecessor of the modern configuration, was invented by another Englishman, Alfred Charles South of London, in 1899.

Another tattoo machine was developed in 1970 by the german tattoo artists H.H. "Samy" Streckenbach (1929-2001) and Manfred Kohrs.

Dyes and pigments

Main article: Tattoo ink

Early tattoo inks were obtained directly from nature and were extremely limited in pigment variety. Today, an almost unlimited number of colors and shades of tattoo ink are mass-produced and sold to parlors worldwide. Tattoo artists commonly mix these inks to create their own unique pigments.

Streckenbach / Kohrs tattoo machine at work 1976

A wide range of dyes and pigments can be used in tattoos, from inorganic materials like titanium dioxide and iron oxides to carbon black, azo dyes, and acridine, quinoline, phthalocyanine and naphthol derivates, dyes made from ash, and other mixtures. Iron oxide pigments are used in greater extent in cosmetic tattooing.

Modern tattooing inks are carbon based pigments that have uses outside of commercial tattoo applications. In 2005 at Northern Arizona University a study characterized the makeup of tattoo inks (Finley-Jones and Wagner). The FDA expects local authorities to legislate and test tattoo pigments and inks made for the use of permanent cosmetics. In California, the state prohibits certain ingredients and pursues companies who fail to notify the consumer of the contents of tattoo pigments.

There has been concern expressed about the interaction between magnetic resonance imaging (MRI) procedures and tattoo pigments, some of which contain trace metals. Allegedly, the magnetic fields produced by MRI machines could interact with these metal particles, potentially causing burns or distortions in the image. The television show *MythBusters* tested the hypothesis, and found a slight interaction between commonly used tattoo inks and MRI. The interaction was stronger with inks containing high levels of iron oxide.

Professional tattooists rely primarily on the same pigment base found in cosmetics. Amateurs will often use drawing inks such as low grade India ink, but these inks often contain impurities and toxins which can lead to illness or infection.

Studio hygiene

The properly equipped tattoo studio will use biohazard containers for objects that have come into contact with blood or bodily fluids, sharps containers for old needles, and an autoclave for sterilizing tools. Certain jurisdictions also require studios by law to have a sink in the work area supplied with both hot and cold water.

Proper hygiene requires a body modification artist to wash his or her hands before starting to prepare a client for the stencil, between clients, and at any other time where cross contamination can occur. The use of single use disposable gloves is also mandatory. Also, disposable gloves should be taken off after each stage of tattooing. The same gloves should be not be used to clean the tattoo station, tattoo the client, and cleaning the tattoo. The tattoo artist should be changing their disposable glove at each stage. In some states and countries it is illegal to tattoo a minor even with parental consent, and (except in the case of medical tattoos) it is usually not allowed to tattoo impaired persons, people with contraindicated skin conditions, those who are pregnant or nursing, those incapable of consent due to mental incapacity or those under the influence of alcohol or drugs.

Before the tattooing begins the client is asked to approve the final position of the applied stencil. After approval is given the artist will open new, sterile needle packages in front of the client, and always use new, sterile or sterile disposable instruments and supplies, and fresh ink for each session (loaded into disposable ink caps which are discarded after each client). Also, all areas which may be touched with

contaminated gloves will be wrapped in clear plastic to prevent cross-contamination. Equipment that cannot be autoclaved (such as counter tops, machines, and furniture) will be wiped with an approved disinfectant.

Membership in professional organizations, or certificates of appreciation/achievement, generally helps artists to be aware of the latest trends. However, many of the most notable tattooists do not belong to any association. While specific requirements to become a tattooist vary between jurisdictions, many mandate only formal training in bloodborne pathogens, and cross contamination. The local department of health regulates tattoo studios in many jurisdictions.

For example, according to the health departments in Oregon and Hawaii, tattoo artists in these states are required to take and pass a test ascertaining their knowledge of health and safety precautions, as well as the current state regulations. Performing a tattoo in Oregon state without a proper and current license or in an unlicensed facility is a felony offense. Tattooing was legalized in New York City in 1997, and in Massachusetts and Oklahoma between 2002 and 2006.

Aftercare

Tattoo artists, and people with tattoos, vary widely in their preferred methods of caring for new tattoos. Some artists recommend keeping a new tattoo wrapped for the first twenty-four hours, while others suggest removing temporary bandaging after two hours or less. Many tattooists advise against allowing too much contact with hot tub or pool water, or soaking in a tub for the first two weeks. This is to prevent the tattoo ink from washing out or fading due to over-hydration and to avoid infection from exposure to bacteria and chlorine. In contrast, other artists suggest that a new tattoo be bathed in very hot water early and often.

General consensus for care advises against removing the scab that forms on a new tattoo, and avoiding exposing one's tattoo to the sun for extended periods for at least 3 weeks; both of these can contribute to fading of the image. Furthermore, it is agreed that a new tattoo needs to be kept clean. Various products may be recommended for application to the skin, ranging from those intended for the treatment of cuts, burns and scrapes, to cocoa butter, hemp, salves, lanolin, A&D, Bepanthen or Aquaphor. Oil based ointments are almost always recommended to be used in very thin layers due to their inability to evaporate and therefore over-hydrate the already perforated skin. In recent years, specific commercial products have been developed for tattoo aftercare. Although opinions about these products vary, there is near total agreement that either alone or in addition to some other product, soap and warm water work well to keep a tattoo clean and free from infection. Ultimately, the amount of ink that remains in the skin throughout the healing process determines, in large part, how robust the final tattoo will look. If a tattoo becomes infected (uncommon but possible if one neglects to properly clean their tattoo) or if the scab falls off too soon (e.g., if it absorbs too much water and sloughs off early or is picked or scraped off), then the ink will not be properly fixed in the skin and the final image will be negatively affected.

Health risks

Main article: Tattoo medical issues

Because it requires breaking the skin barrier, tattooing may carry health risks, including infection and allergic reactions. Modern tattooists reduce such risks by following universal precautions, working with single-use items, and sterilizing their equipment after each use. Many jurisdictions require that tattooists have blood-borne pathogen training, such as is provided through the Red Cross and OSHA.

Modern tattoo artist's nitrile gloves and sterilized equipment

In amateur tattoos, such as those applied in prisons, however, there is an elevated risk of infection. Infections that can theoretically be transmitted by the use of unsterilized tattoo equipment or contaminated ink include surface infections of the skin, herpes simplex virus, tetanus, staph, fungal infections, some forms of hepatitis, tuberculosis, and HIV. In the United States there have been no reported cases of HIV contracted via commercially-applied tattooing process.

Tattoos increase the risk of hepatic disease, which will be exacerbated by the steatohepatitis that alcohol induces. Therefore it has been highly recommended not to drink for at least two months after getting a tattoo, though the risk will still not have completely diminished.[citation needed] Hepatic disease is a serious condition frequently involving jaundicing—to be exact, the yellowing appearance of the skin, furthermore, spontaneous bleeding primarily from the joints. Risk of infections is also increased, and coupled with hepatic disease, can result in exsanguination.

Tattoo inks have been described as "remarkably nonreactive histologically". However, cases of allergic reactions to tattoo inks, particularly certain colors, have been medically documented. Occasionally, when a blood vessel is punctured during the tattooing procedure a bruise/hematoma may appear. This is sometimes due to nickel in an ink pigment, which is a common metal allergy.

Tattoo removal

Main article: Tattoo removal

While tattoos are considered permanent, it is sometimes possible to remove them with laser treatments, fully or partially. Typically, black and darker colored inks can be removed more completely. An ink trademarked as InfinitInk is designed to be removed in a single laser treatment. The expense and pain of removing tattoos will typically be greater than the expense and pain of applying them. Some jurisdictions will pay for the voluntary removal of gang tattoos. Pre-laser tattoo removal methods include dermabrasion, salabrasion (scrubbing the skin with salt), cryosurgery, and excision which is sometimes still used along with skin grafts for larger tattoos.

Temporary tattoos

Main article: Temporary tattoo

Temporary tattoos are popular with models and children as they involve no permanent alteration of the skin but produce a similar appearance that can last anywhere from a few days to several weeks. The most common style is a type of body sticker similar to a decal, which is typically transferred to the skin using water. Although the design is waterproof, it can be removed easily with oil-based creams. Originally inserted as a prize in bubble gum packages, they consisted of a poor quality ink transfer that would easily come off with water or rubbing. Today's vegetable dye temporaries can look extremely realistic and adhere up to 3 weeks due to a layer of glue similar to that found on an adhesive bandage.

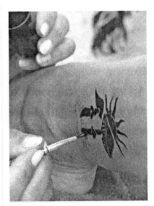

Temporary tattoo being applied to a human ankle

Henna tattoos (*Mehndi*) and silver nitrate stains that appear when exposed to ultraviolet light can take up to two weeks to fade from the skin. Temporary airbrush tattoos (TATs) are applied by covering the skin with a stencil and spraying the skin with ink. In the past, this form of tattoo only lasted about a week. With the newest inks, tattoos can reasonably last for up to two weeks.

Types of tattoos

The American Academy of Dermatology distinguishes 5 types of tattoos: Traumatic tattoos, also called "natural tattoos", that result from injuries, especially asphalt from road injuries or pencil lead; Amateur tattoos; Professional tattoos, both via traditional methods and modern tattoo machines; Medical tattoos; Cosmetic tattoos, also known as "permanent makeup".

Traumatic tattoos

According to George Orwell, coal miners could develop characteristic tattoos owing to coal dust getting into wounds. This can also occur with substances like gunpowder. Similarly, a traumatic tattoo occurs when a substance such as asphalt is rubbed into a wound as the result of some kind of accident or trauma. These are particularly difficult to remove as they tend to be spread across several different layers of skin, and scarring or permanent discoloration is almost unavoidable depending on the location. In addition, tattooing of the gingiva from implantation of amalgam particles during dental filling placement and removal is possible and not uncommon. A common example of such accidental tattoos is the result of a deliberate or accidental stabbing with a pencil or pen, leaving graphite or ink beneath the skin.

See also

- Chinese character tattoos
- Five Dots Tattoo
- Foreign body reaction
- Legal status of tattooing in the United States
- List of tattoo artists
- Lucky Diamond Rich, world's most tattooed person.

- Marquesan tattoo
- SS blood group tattoo
- Tattoo convention
- Tattooing of Minors Act 1969 (in the UK)
- Tear tattoo
- Three Dots Tattoo
- UV tattoo

References

Bibliography

Anthropological

- Buckland, A. W. (1887) "On Tattooing," in *Journal of the Royal Anthropological Institute of Great Britain and Ireland*, 1887/12, p. 318-328
- Caplan, Jane (ed.) (2000): Written on the Body: the Tattoo in European and American History, Princeton U P
- DeMello, Margo (2000) Bodies of Inscription: a Cultural History of the Modern Tattoo Community, California. Durham NC: Duke University Press
- Fisher, Jill A. (2002). Tattooing the Body, Marking Culture. *Body & Society* 8 (4): pp. 91–107.
- Gell, Alfred (1993) Wrapping in Images: Tattooing in Polynesia, Oxford: Clarendon Press
- Gilbert, Stephen G. (2001) Tattoo History: a Source Book, New York: Juno Books
- Gustafson, Mark (1997) "*Inscripta in fronte*: Penal Tattooing in Late Antiquity," in *Classical Antiquity*, April 1997, Vol. 16/No. 1, p. 79-105
- Hambly, Wilfrid Dyson (1925) The History of Tattooing and Its Significance: With Some Account of Other Forms of Corporal Marking, London: H. F.& G. Witherby (reissued: Detroit 1974)
- Hesselt van Dinter, Maarten (2005) The World of Tattoo; An Illustrated History. Amsterdam, KIT Publishers
- Jones, C. P. (1987) "Stigma: Tattooing and Branding in Graeco-Roman Antiquity," in *Journal of Roman Studies*, 77/1987, pp. 139–155
- Juno, Andrea. *Modern Primitives. Re/Search* #12 (October 1989) ISBN 0965046931
- "Tattooing Among Japan's Ainu People" [1]. Lars Krutak. Retrieved 2009-08-24.
- Lombroso, Cesare (1896) "The Savage Origin of Tattooing," in *Popular Science Monthly*, Vol. IV., 1896
- Raviv, Shaun (2006) Marked for Life: Jews and Tattoos (Moment Magazine; June 2006)
- Comparative study about Ötzi's therapeutic tattoos (L. Renaut, 2004, French and English abstract) [2]

- Robley, Horatio (1896) *Moko, or, Maori tattooing*. London: Chapman and Hall
- Roth, H. Ling (1901) Maori tatu and moko. In: *Journal of the Anthropological Institute* v. 31, January–June 1901
- Rubin, Arnold (ed.) (1988) *Marks of Civilization: Artistic Transformations of the Human Body*, Los Angeles: UCLA Museum of Cultural History
- Sanders, Clinton R. (1989) *Customizing the Body: the Art and Culture of Tattooing*. Philadelphia: Temple University Press
- Sinclair, A. T. (1909) "Tattooing of the North American Indians," in *American Anthropologist* 1909/11, No. 3, p. 362-400

Popular and artistic

- Green, Terisa. *Ink: The Not-Just-Skin-Deep Guide to Getting a Tattoo* ISBN 0-451-21514-1
- Green, Terisa. *The Tattoo Encyclopedia: A Guide to Choosing Your Tattoo* ISBN 0-7432-2329-2
- Krakow, Amy. *Total Tattoo Book* ISBN 0-446-67001-4

Medical

- Centers for Disease Control and Prevention, *CDC's Position on Tattooing and HCV Infection* [3], retrieved June 12, 2006
- National Institute for Occupational Safety and Health, *Body Art (workplace hazards)* [4], retrieved September 15, 2008
- United States Food and Drug Administration, "Tattoos and Permanent Makeup" [5], *CFSAN/Office of Cosmetics and Colors (2000; updated [2004, 2006])*, retrieved June 12, 2006
- Haley R.W. and Fischer R.P., *Commercial tattooing as a potential source of hepatitis C infection*, Medicine, March 2000;80:134-151

History of tattooing

Main article: Tattoo

Tattooing in prehistoric times

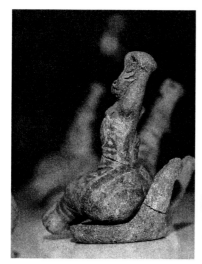

Supposed Neolithic Tattoo, discovered on modern day Romania, PreCucuteni Culture, clay figure 4900-4750BC.

Tattooing has been a Eurasian practice since Neolithic times. "Ötzi the Iceman", dated circa 3300 BC, bearing 57 tattoos: a cross on the inside of the left knee, six straight lines 15 centimeters long above the kidneys and numerous small parallel lines along the lumbar, legs and the ankles, exhibiting possible therapeutic tattoos (treatment of arthritis). Tarim Basin (West China, Xinjiang) revealed several tattooed mummies of a Western (Western Asian/European) physical type. Still relatively unknown (the only current publications in Western languages are those of J P. Mallory and V H. Mair, *The Tarim Mummies*, London, 2000), some of them could date from the end of the 2nd millennium BC.

One tattooed Mummy (c. 300 BC) was extracted from the permafrost of Altaï in the second half of the 15th century (the Man of Pazyryk, during the 1940s; one female mummy and one male in Ukok plateau, during the 1990s). Their tattooing involved animal designs carried out in a curvilinear style. The Man of Pazyryk, a Scythian chieftain, is tattooed with an extensive and detailed range of fish, monsters and a series of dots that lined up along the spinal column (lumbar region) and around the right ankle (*illustrated at right*).

Tattooing in the ancient world

Chinese

Tattooing was popular among many ethnic minorities in China since ancient time. However, among the Han Chinese (the major ethnic group) Tattoo has been associated with barbaric, criminals, gangsters and bandits since at least Zhou Dynasty (1045 BC to 256 BC). Tattooing Chinese character "Prisoner" (囚) or other characters on convicted's or slave's face was a practice until the last dynasty Qing Dynasty (1644 to 1912).

Tattooing has been featured in one of the Four Classic Novels in Chinese literature, Water Margin, in which at least three of the 108 characters, Lu Zhi shen (鲁智深), Shi Jin (史進) and Yan Ching (燕青)

are described as having tattoos covering nearly the whole of their bodies. Wu Song (武松) has tattoo on his face due to killing Xi Men Qing (西门庆) with vengeance. In addition, Chinese legend has it that the mother of Yue Fei (岳飛), the most famous general of the Song Dynasty, tattooed the words jing zhong bao guo (精忠報國) on his back with her sewing needle before he left to join the army, reminding him to "repay his country with pure loyalty".

Marco Polo wrote of Quanzhou "Many come hither from Upper India to have their bodies painted with the needle in the way we have elsewhere described, there being many adepts at this craft in the city."

The traditional Han Chinese view especially Confucianism believes that the body is a gift of parents and continuation of the bloodline of the ancestors. Damaging the body is a grave offense. Tattooing and piercing (except women's ear piercing) are generally not accepted by the community. This view can be reflected by the fact that many Han Chinese was killed at the beginning of Qing Dynasty when they refuse to obey the Manchu government's order that all Han Chinese men to shave their forehead (the Manchu hair style), see "Queue Order".

Egypt and India

Main articles: Henna and Mehndi

Henna and Mehndi were popular in ancient India and ancient Egypt and still remain popular today in the Indian subcontinent, Middle East and North Africa.

Philippines

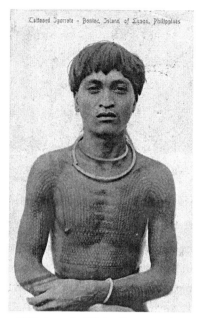

Tattooed Igorrote - Bonloc, Island of Luzon, Philippines

1908 photo of a Filipino Bontoc warrior bearing a Head hunters 'Chaklag' Tattoo

Tattooing has been a part of Filipino tribal life since pre-Hispanic colonisation of the Philippine Islands, When the Spanish first landed in the Philippine Islands, they were met by the tribal people of the Visayas, who had full body tattooing, the Spanish dubbed these Islands as "La Isla De Los Pintados" or "The Islands of the Painted Ones". Tattooing in the Philippines is a tribal form of rank and accomplishments, some tribes believed that tattoo's had magical qualities. The more famous tattooed Filipino Tribes where the tribal peoples of the mountains of North Luzon, especially among the Bontoc Igorot, Kalinga, and Ifugao peoples, which were infamous for Head-hunting. A tribal member received a tattoo (known as a "Chaklag") which meant they have taken the head of an enemy tribe or warrior. There are many very different variations, traditions and styles of tattooing in the Philippines, most depend on the region and tribe they come from as each vary.

Filipino tattooing was first documented by the European Spanish explorers as they landed among the Islands in the late 16th century. Before European exploration it was a widespread tradition among the islands. Tattooing was set around mostly Tribal groups of the Philippines, which tattooing was a sign of Rank and power in the tribal community, many Tattoos could only be attained by accomplishing a task, or passage of rites. Women in Filipino tribal society also traditionally tattooed themselves, and tattooing was seen as a form of beauty among women. Notably women of the Luzon mountain tribes received full arm and chest tattooing, whilst in the Visayas and Mindanao they typically only tattooed their hands and wrists.

Indonesia

Several Indonesian tribes have a tattoo culture. One notable example is the Dayak people of Kalimantan in Borneo (Bornean traditional tattooing).

Dayak tattooing in progress.

Europe

Pre-Christian Germanic, Celtic and other central and northern European tribes were often heavily tattooed, according to surviving accounts. The Picts were famously tattooed (or scarified) with elaborate dark blue woad (or possibly copper for the blue tone) designs. Julius Caesar described these tattoos in Book V of his *Gallic Wars* (54 BCE).

Ahmad ibn Fadlan also wrote of his encounter with the Scandinavian Rus' tribe in the early 10th century, describing them as tattooed from "fingernails to neck" with dark blue "tree patterns" and other "figures." During the gradual process of Christianization in Europe, tattoos were often considered remaining elements of paganism and generally legally prohibited.

According to Robert Graves in his book *The Greek Myths* tattooing was common amongst certain religious groups in the ancient Mediterranean world, which may have contributed to the prohibition of tattooing in Leviticus. However, during the classic Greek period, tattooing was only common among slaves.

Japan

Main article: Irezumi

Tattooing for spiritual and decorative purposes in Japan is thought to extend back to at least the Jōmon or Paleolithic period (approximately 10,000 BCE) and was widespread during various periods for both the Japanese and the native Ainu. Chinese visitors observed and remarked on the tattoos in Japan (300 BCE).

Between 1603 - 1868 Japanese tattooing was only practiced by the "ukiyo-e" (The floating world culture). generally firemen, manual workers and prostitutes wore tattoos which communicated their status. Between 1720 - 1870 Criminals were tattooed as a visible mark of punishment, this actually replaced having ears and noses removed. A criminal would often receive a single ring on their arm for each crime committed which easily conveyed their criminality. This practice was eventually abolished by the "Meji" government who banned the art of tattooing altogether, viewing it as barbaric and unrespectable, this subsequently forced a sub culture of criminals and outcasts, many of whom were the old Samurai warriors ("Ronin" - Master less). These people had no place in "decent society" and were frowned upon, they were kept separate and simply could not integrate into mainstream society because of their obvious visible tattoos, this forced them into criminal activities which ultimately formed the

roots for the modern Japanese mafia - "Yakuza" for which tattoos in Japan have almost become synonymous.

Middle East

An archaic practice in the Middle East involved people cutting themselves and rubbing in ash during a period of mourning after an individual had died. It was a sign of respect for the dead and a symbol of reverence and a sense of the profound loss for the newly departed; and it is surmised that the ash that was rubbed into the self-inflicted wounds came from the actual funeral pyres that were used to cremate bodies. In essence, people were literally carrying with them a reminder of the recently deceased in the form of tattoos created by ash being rubbed into shallow wounds cut or slashed into the body, usually the forearms.

Samoa

The traditional male tattoo in Samoa is called the pe'a. The traditional female tattoo is called the malu. The word *tattoo* is believed to have originated from the Samoan word *tatau*.

When the Samoan Islands were first seen by Europeans in 1722 three Dutch ships commanded by Jacob Roggeveen visited the eastern island known as Manua. A crew member of one of the ships described the natives in these words, "They are friendly in their speech and courteous in their behavior, with no apparent trace of wildness or savagery. They do not paint themselves, as do the natives of some other islands, but on the lower part of the body they wear artfully woven silk tights or knee breeches. They are altogether the most charming and polite natives we have seen in all of the South Seas..."

The ships lay at anchor off the islands for several days, but the crews did not venture ashore and didn't even get close enough to the natives to realize that they were not wearing silk leggings, but their legs were completely covered in tattoos.

In Samoa, the tradition of applying tattoo, or tatau, by hand has been unbroken for over two thousand years. Tools and techniques have changed little. The skill is often passed from father to son, each tattoo artist, or tufuga, learning the craft over many years of serving as his father's apprentice. A young artist-in-training often spent hours, and sometimes days, tapping designs into sand or tree bark using a special tattooing comb, or au. Honoring their tradition, Samoan tattoo artists made this tool from sharpened boar's teeth fastened together with a portion of the turtle shell and to a wooden handle.

Traditional Samoan tattooing of the "pe'a", body tattoo, is an ordeal that is not lightly undergone. It takes many weeks to complete. The process is very painful and used to be a necessary prerequisite to receiving a matai title; this however is no longer the case. Tattooing was also a very costly procedure.

It was not uncommon for half a dozen boys to be tattooed at the same time, requiring the services of four or more artists. It was not just the men who received tattoos, but the women too; their designs are of a much lighter nature rather than having the large areas of solid dye which are frequently seen in

men's tattoos. The tattooing of women was not nearly as ritualized like men's were.

Samoan society has long been defined by rank and title, with chiefs (ali'i) and their assistants, known as talking chiefs (tulafale). The tattooing ceremonies for young chiefs, typically conducted at the time of puberty, were part of their ascendance to a leadership role. The permanent marks left by the tattoo artists would forever celebrate their endurance and dedication to cultural traditions. The pain was extreme and the risk of death by infection was a concern; to back down from tattooing was to risk being labeled a "pala'ai" or coward. Those who could not endure the pain and abandoned their tattooing were left incomplete, would be forced to wear their mark of shame throughout their life. This would forever bring shame upon their family so it was avoided at all cost.

The Samoan tattooing process used a number of tools which remained almost unchanged since their first use. "Autapulu" is a wide tattooing comb used to fill in the large dark areas of the tattoo. "Ausogi'aso tele" is a comb used for making thick lines. "Ausogi'aso laititi" is a comb used for making thin lines. "Aumogo" small comb is used for making small marks. "Sausau" is the mallet is used for striking the combs. It is almost two feet in length and made from the central rib of a coconut palm leaf. "Tuluma" is the pot used for holding the tattooing combs. Ipulama is the cup used for holding the dye. The dye is made from the soot collected from burnt lama nuts. "Tu'I" used to grind up the dye. These tools were primarily made out of animal bones to ensure sharpness.

The tattooing process itself would be 5 sessions, in theory. These 5 sessions would be spread out over 10 days in order for the inflammation to subside. The steps are as follows.

I. O le Taga Tapulu (back and small of the back) In the first session the height to which the tattoo will rise is decided (Ano le Tua), this is always such that the top of the design will show above the lavalava. Then the va'a, pula tama and pula tele are outlined and the design filled in.

II. O le Taga Fai'aso (the posterior) The aso fa'aifo are completed around to the abdomen and the 'asolaititi are finished. Next to be added are the saemutu, which vary in number depending upon social status. A matai will have four an orator three and anyone else would have two. Where it meets the 'ivimutu at the anus it is called tafaufile, where it covers the perineum it is called tasele, where it covers the scrotum it is called tafumiti and the area over the penis is called tafito. Needless to say this is very painful.

III. Taga Tapau The lausae, an area of solid tattooing, is added to the thighs beneath the aso e lua.

IV. Taga o Fusi ma Ulumanu The fourth session is the tattooing of the ulumanu, from the center of the thigh up to the inner groin.

V. 'Umaga (the end) The final sessions involves the tattooing of the abdomen, the area that covers the navel being called the pute, and is apparently the most painful part of the whole process.

Christian missionaries from the west attempted to purge tattooing among the Samoans, thinking it barbaric and inhumane. Many young Samoans resisted mission schools since they forbade them to wear tattoos. But over time attitudes relaxed toward this cultural tradition and tattooing began to

reemerge in Samoan culture.

Persia

In Persian culture, tattooing, body painting, and body piercing has been around for thousands of years. The statues and stone carvings remained from Achaemenid Empire (550–330 B.C.) prove existence of body piercing and earrings on ancient Persian gods, kings, and even soldiers. The most famous literal document about Persian tattoo goes back to about 800 years ago when Rumi, the famous Persian poet, narrates a story about a man who proudly asks to get a lion tattoo but he changes his mind once he experiences the pain coming out of the tattoo needle.

Reintroduction in the Western world

It was thought that many of the Anglo-Saxon kings of England were tattooed, but much of this was conjecture.

Sir Martin Frobisher (1535–1595) on May 31, 1577 set out on his second voyage from Harwich, England with 3 ships and about 120 men to find a north west passage to China and the promise of gold ore. Frobisher took prisoner a native Inuit man and a woman with a child, upon his return to England the woman having tattoos on her chin and forehead was a great attraction at the court of Elizabeth I. All three died within a month.

In 1691 William Dampier brought to London a native of the western part of New Guinea (now part of Indonesia) who had a tattooed body and became known as the "Painted Prince".

Between 1766 and 1779, Captain James Cook made three voyages to the South Pacific, the last trip ending with Cook's death in Hawaii in February, 1779. When Cook and his men returned home to Europe from their voyages to Polynesia, they told tales of the 'tattooed savages' they had seen. The word "tattoo" itself comes from the Tahitian *tatau*, and was introduced into the English language by Cook's expedition.

Cook's Science Officer and Expedition Botanist, Sir Joseph Banks, returned to England with a tattoo. Banks was a highly regarded member of the English aristocracy and had acquired his position with Cook by putting up what was at the time the princely sum of some ten thousand pounds in the expedition. In turn, Cook brought back with him a tattooed Raiatean man, Omai, whom he presented to King George and the English Court. Many of Cook's men, ordinary seamen and sailors, came back with tattoos, a tradition that would soon become associated with men of the sea in the public's mind and the press of the day. In the process sailors and seamen re-introduced the practice of tattooing in Europe and it spread rapidly to seaports around the globe.

It was in Tahiti aboard the Endeavour, in July of 1769, that Cook first noted his observations about the indigenous body modification and is the first recorded use of the word tattoo. In the Ship's Log Cook recorded this entry: "Both sexes paint their Bodys, Tattow, as it is called in their Language. This is

done by inlaying the Colour of Black under their skins, in such a manner as to be indelible."

Cook went on to write, "This method of Tattowing I shall now describe...As this is a painful operation, especially the Tattowing of their Buttocks, it is performed but once in their Lifetimes."

The British Royal Court must have been fascinated with Omai's tattoos, because the future King George V had himself inked with the 'Cross of Jerusalem' when he traveled to the Middle East in 1892. During a visit to Japan he also received a dragon on the forearm from the needles of Hori Chiyo, an acclaimed tattoo master. George's sons, the Dukes of Clarence and York were also tattooed in Japan while serving in the British Admiralty, solidifying what would become a family tradition.

Taking their sartorial lead from the British Court, where Edward VII followed George V's lead in getting tattooed; King Frederick IX of Denmark, the King of Romania, Kaiser Wilhelm II, King Alexander of Yugoslavia and even Tsar Nicholas II of Russia, all sported tattoos, many of them elaborate and ornate renditions of the Royal Coat of Arms or the Royal Family Crest. King Alfonso XIII of modern Spain also had a tattoo.

Tattooing spread among the upper classes all over Europe in the 19th century, but particularly in Britain where it was estimated in Harmsworth Magazine in 1898 that as many as one in five members of the gentry were tattooed. There, it was not uncommon for members of the social elite to gather in the drawing rooms and libraries of the great country estate homes after dinner and partially disrobe in order to show off their tattoos. Aside from her consort Prince Albert of Saxe-Coburg and Gotha, there are persistent rumours that Queen Victoria had a small tattoo in an undisclosed 'intimate' location; Denmark's king Frederick was filmed showing his tattoos taken as a young sailor. Winston Churchill's mother, Lady Randolph Churchill, had a tattoo of a snake around her wrist, which she covered when the need arose with a specially crafted diamond bracelet. Carrying on the family tradition, Winston Churchill had an anchor tattooed on his forearm.

Religious prohibitions

The Jewish Positions

Orthodox Jews, in strict application of Halakha (Jewish Law), believe Leviticus 19:28 [1] prohibits getting tattoos: *Do not make gashes in your skin for the dead. Do not make any marks on your skin. I am God.* One reading of Leviticus is to apply it only to the specific ancient practice of rubbing the ashes of the dead into wounds; but modern tattooing is included in other religious interpretations. Orthodox/Traditional Jews also point to Shulchan Aruch, Yoreh De'ah 180:1, that elucidates the biblical passage above as a prohibition against markings beyond the ancient practice, including tattoos. Maimonides concluded that regardless of intent, the act of tattooing is prohibited (Mishneh Torah, Laws of Idolatry 12:11).

Conservative Jews point to the next verse of the Shulchan Aruch (Yoreh De'ah 180:2), "If it [the tattoo] was done in the flesh of another, the one to whom it was done is blameless" — this is used by them to

say that tattooing yourself is different from obtaining a tattoo, and that the latter may be acceptable. Orthodox Jews disagree, and read the text as referring to forced tattooing—as was done during the Holocaust—which is not considered a violation of Jewish Law on the part of the victim. In another vein, cutting into the skin to perform surgery and temporary tattooing used for surgical purposes (e.g.: to mark the lines of an incision) are permitted in the Shulhan Arukh 180:3.

In most sectors of the religious Jewish community, having a tattoo does not prohibit participation, and one may be buried in a Jewish cemetery and participate fully in all synagogue ritual. In stricter sectors of the community, however, a community may have a *psak* (ruling or responsa with the weight of Halakha) that may forbid one's burial in a cemetery that comes under that rulingWikipedia:Disputed statement. Many of these communities, most notably the Modern Orthodox, accept laser removal of the tattoo as teshuvah (repentance), even when it is removed post-mortem (see Tahara).

Reform Jews and Reconstructionist Jews neither condemn nor condone tattooing.

Christian Positions

Leviticus 19:28 is often cited by Christians as a verse prohibiting tattoos. According to the King James Version of the Bible, the verse states, "Ye shall not make any cuttings in your flesh for the dead, nor print any marks upon you: I am YHVH." While it may appear that the passage disallows any markings of the flesh, even applying to the modern-day use of tattoos, it is likely the passage refers specifically to the form of mourning discussed above (see Middle East section). Christians who believe that the religious doctrines of the Old Testament are superseded by the New Testament may still find explicit or implicit directives against tattooing in Christian scripture, in ecclesiastical law, or in church-originated social policy. Others who disapprove or approve of tattoos as a social phenomenon may cite other verses to make their point.

For example, Revelation 14:1, 17:5, and 19:16 are cited as passages in which names are written on foreheads and the thigh of Christ, respectively. In this case, however, it is possibly metaphorical as the language is prophetic.

There is no prohibition against tattoo within the Catholic Church, provided that the tattoo is not an image directly opposed to Catholic teaching or religious sentiment, and that an inordinate amount of money is not spent on the process. At the Catholic council of Calcuth in Northumberland in A.D. 786, a Christian bearing a tattoo "for the sake of God" (i.e., a religious tattoo in the form of a cross, a monogramme of Christ, or a saint's image) was commended as praiseworthy.

Muslim positions

Sharia (or Islamic Law), the majority of Sunni Muslims hold that tattooing is religiously forbidden (along with most other forms of 'permanent' physical modification). This view arises from references in the Prophetic Hadith which denounce those who attempt to change the creation of God (Arabic: Allah), in what is seen as excessive attempts to beautify that which was already perfected. The human being is seen as having been ennobled by God (Arabic: Allah), the human form viewed as created beautiful, such that the act of tattooing would be a form of mutilation.

External links

- * excerpt from *Tattoo History: A Source Book* [2]
- History of Persian Tattoos [3]

Body Modification

Body modification

Body modification (or **body alteration**) is the deliberate altering of the human body for non-medical reasons, such as sexual enhancement, a rite of passage, aesthetic reasons, denoting affiliation, trust and loyalty, religious reasons, shock value, and self-expression.. It can range from the socially acceptable decoration (e.g., pierced ears in many societies) to the religiously mandated (e.g., circumcision in a number of cultures), and everywhere in between. Body art is the modification of any part of the human body for spiritual, religious, artistic or aesthetic reasons.

Types of body modification

Explicit ornaments

- Body piercing - Permanent placement of jewelry through an artificial fistula; sometimes further modified by stretching
- Ear piercing - The most common type of body modification
- Pearling - Also known as genital beading
- Neck ring- Multiple Neck rings are worn to stretch the neck.
- Scrotal implants
- Eyeball tattooing - Injection of a pigment into the cornea.
- Extraocular implant (eyeball jewelry) - The implantation of jewelry in the outer layer of the eye.
- Surface Piercing - A surface piercing is a piercing where the entrance and exit holes are pierced through the same flat area of skin.
- Microdermal implants
- Transdermal implant - implantation of an object below the dermis, but which exits the skin at one or more points

Surgical augmentation

In contrast to the explicit ornaments, the following procedures are primarily not meant to be exposed *per se*, but rather function to augment another part of the body, like the skin in a subdermal implant.

- Breast implants - Insertion of silicone bags filled with silicone gel or saline solution into the breasts to increase their size, or to restore a more normal appearance after surgery
- Silicone injection
- Subdermal implant - implantation of an object that resides entirely below the dermis, including Horn implants

Removal or split

- Hair cutting
- Hair removal
- Male circumcision - the partial or full removal of the foreskin, sometimes also the frenulum--conversely some men choose to take up foreskin restoration.
- Female genital cutting - removal of the labia minora or the clitoral hood
- Frenectomy
- Genital bisection - splitting of both the underside and the top of the penis, including Genital inversion
- Meatotomy - splitting of the underside of the glans penis
- Headsplitting - splitting of both the underside and the top of the glans penis
- Nipple removal
- Nipple splitting
- **Nullification** involves the voluntary removal of body parts. Body parts that are removed by those practicing body nullification are for example fingers, penis (penectomy), testicles (castration), clitoris, labia or nipples. Sometimes people who desire a nullification may be diagnosed with body integrity identity disorder or apotemnophilia.
- Subincision - splitting of the underside of the penis, also called urethrotomy
- Suspensory ligament of the penis
- Lingual frenectomy
- Tongue splitting - bisection of the tongue similar to a snake's
- Trepanation, drilling a hole into the skull

Applying long-term force

Body modifications occurring as the end result of long term activities or practices

- Corsetry or tightlacing - binding of the waist and shaping of the torso
- Cranial binding - modification of the shape of infants' heads, now extremely rare
- Breast ironing - Pressing (sometimes with a heated object) the breasts of a pubescent female to prevent their growth.
- Foot binding - compression of the feet of girls to modify them for aesthetic reasons
- Anal stretching
- Non-surgical elongation of organs by prolonged stretching using weights or spacing devices. Some cultural traditions prescribe for or encourage members of one sex (or both) to have one organ stretched till permanent re-dimensioning has occurred, such as:

 - The 'giraffe-like' stretched necks (sometimes also other organs) of women among the Burmese Kayan tribe, the result of wearing brass coils around them. This compresses the collarbone and upper ribs but is not medically dangerous. It is a myth that removing the rings will cause the neck to 'flop'; Padaung women remove them regularly for cleaning etc.
 - Stretched lip piercings - achieved by inserting ever larger plates, such as those made of clay used by some Amazonian tribes.

Others

- Branding - controlled burning or cauterizing of tissue to encourage intentional scarring
- Ear shaping (which includes Ear cropping , Ear pointing or "elfing")
- Scarification - cutting or removal of dermis with the intent to encourage intentional scarring or keloiding
- Tooth filing
- Bodybuilding

Controversy

Some sources of controversy stem from the notion of attempting to artificially beautify the natural form of the body, often leading to charges of disfigurement and mutilation. Extreme forms of body modification are occasionally viewed as symptomatic of body dysmorphic disorder, other mental illnesses, or as an expression of unchecked vanity. Unlicensed surgery (i.e. the plastic surgery field) performed outside of a medical environment can often be life-threatening, and is illegal in most countries and states.

"Disfigurement" and "mutilation" (regardless of any appreciation this always applies objectively whenever a bodily function is gravely diminished or lost, as with castration) are terms used by opponents of body modification to describe certain types of modifications, especially non-consensual ones. Those terms are used fairly uncontroversially to describe the victims of torture,

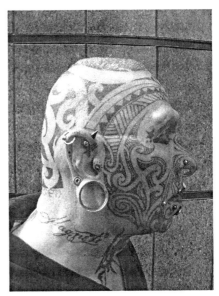

The head of a man with conspicuous tattoos and other body modifications

who have endured damage to ears, eyes, feet, genitalia, hands, noses, teeth, and/or tongues, including amputation, burning, flagellation, piercing, skinning, and wheeling[citation needed]. "Genital mutilation" is also used somewhat more controversially to describe certain kinds of socially prescribed modifications to the genitals, such as circumcision, female circumcision, castration, and surgeries performed to conform the genitals of individuals with intersex conditions to those of typical males or females[citation needed].

Individuals known for extensive body modification

- Rick Genest, has had his entire head and torso tattooed so as to appear like a human skeleton
- Pete Burns, had extensive polyacrylamide injections into his lips, along with cheek implants, several nose re-shapings and many tattoos
- Elaine Davidson, the "Most Pierced Woman" according to the Guinness World Records.
- The Enigma
- Lolo Ferrari
- Julia Gnuse ("The Illustrated Lady")
- Cindy Jackson, had more cosmetic surgery procedures than anyone else in the world
- Katzen ("Cat woman")

- Tom Leppard, formerly considered by the *Guinness Book of World Records* to be the world's most tattooed man.
- Erik Sprague ("The Lizardman"), with sharpened teeth, full-body tattoo of green scales, bifurcated tongue, and recently, green-inked lips
- The Scary Guy, his nose, eyebrows and ears are pierced and tattoos cover 85 percent of his body.
- Lucky Diamond Rich, holds the Guinness world record as "the world's most tattooed person" as of 2006
- Hao Lulu, extensive cosmetic surgery in 2003 to alter her appearance, tagged "The Artificial Beauty"
- Horace Ridler ("The Great Omi"), tattooed in a pattern of curved black stripes, often described as zebra-like
- Pauly Unstoppable, the first person to get the white of his eye tattooed
- Stalking Cat ("Cat man")
- Stelarc, got a cell-cultivated ear implanted into his left arm
- Jocelyn Wildenstein ("Lion Queen/Cat Woman")
- Fakir Musafar, having exposed himself to body piercing, tightlacing, scarification, tattooing and suspension

See also

- Adornment
- Apotemnophilia
- Attraction to disability
- Bioethics
- Blood ritual
- BME, a large website devoted to body modification
- Church of Body Modification
- Deformity
- Fakir Musafar
- First haircut
- Meatotomy
- Suspension (body modification)
- Transhumanism
- Rhinoplasty

External links

- The Official Body Modification Organization [1]
- New Zealand Body Modification Community [2]
- Pictures of scarification in Africa [3] - Features by Jean-Michel Clajot, Belgian photographer
- Body Modification E-Zine Encyclopedia entry showing various inappropriate uses of ear piercing instruments [4]
- Body Modification E-Zine article on the Studex System 75 [5]
- Church of Body Modification [6]
- The Scary Guy's Website [7]

Body piercing

Body piercing, a form of body modification, is the practice of puncturing or cutting a part of the human body, creating an opening in which jewellery may be worn. The word piercing can refer to the act or practice of body piercing, or to an opening in the body created by this act or practice. While the history of body piercing is obscured by a lack of scholarly reference and popular misinformation, ample evidence exists to document that it has been practiced in various forms by both sexes since ancient times throughout the world.

Ear piercing and nose piercing have been particularly widespread and are well represented in historical records and among grave goods. The oldest mummified remains ever discovered were sporting earrings, attesting to the existence of the practice more than 5,000 years ago. Nose piercing is documented as far back as 1500 BC. Piercings of these types have been documented globally, while lip and tongue piercings were historically found in African and American

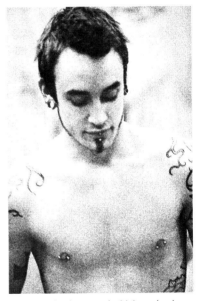

Nipple piercings, vertical labret piercing and a stretched ear

tribal cultures. Nipple and genital piercing have also been practiced by various cultures, with nipple piercing dating back at least to Ancient Rome while genital piercing is described in Ancient India ca. 320 to 550 AD The history of navel piercing is less clear. The practice of body piercing has waxed and waned in Western culture, but it has experienced an increase of popularity since World War II, with sites other than the ears gaining subcultural popularity in the 70s and spreading to mainstream in the 1990s.

The reasons for piercing or not piercing are varied. Some people pierce for religious or spiritual reasons, while others pierce for self-expression, for aesthetic value, for sexual pleasure, to conform to their culture or to rebel against it. Some forms of piercing remain controversial, particularly when applied to youth. The display or placement of piercings have been restricted by schools, employers and religious groups. In spite of the controversy, some people have practiced extreme forms of body piercing, with Guinness bestowing World Records on individuals with hundreds and even thousands of permanent and temporary piercings.

Contemporary body piercing practices emphasize the use of safe body piercing materials, frequently utilizing specialized tools developed for the purpose. Body piercing is an invasive procedure with some risks, including allergic reaction, infection, excessive scarring and unanticipated physical injuries, but such precautions as sanitary piercing procedures and careful aftercare are emphasized to minimize the likelihood of encountering serious problems. The healing time required for a body piercing may vary widely according to placement, from as little as a month for some genital piercings to as much as two full years for the navel.

History

Body adornment has only recently become a subject of serious scholarly research by archaeologists, who have been hampered in studying body piercing by a sparsity of primary sources. Early records rarely discussed the use of piercings or their meaning, and while jewellery is common among grave goods, the deterioration of the flesh that it once adorned makes it difficult to discern how the jewellery may have been used. Also, the modern record has been infiltrated with the 20th century inventions of piercing enthusiast Doug Malloy. In the 1960s and 1970s, Malloy marketed contemporary body

An earring found in an Alamannic grave in Germany, dated ca. 6th or 7th century AD

piercing by giving it the patina of history. His pamphlet *Body & Genital Piercing in Brief* included such commonly reproduced urban legends as the notion that Prince Albert invented the piercing that shares his name in order to tame the appearance of his large penis in tight trousers and that Roman centurions attached their capes to nipple piercings. Some of Malloy's myths are reprinted as fact in subsequently published histories of piercing.

Ear piercing

Ear piercing has been practiced all over the world since ancient times, particularly in tribal cultures. There is considerable written and archaeological evidence of the practice. Mummified bodies with pierced ears have been discovered, including the oldest mummified body discovered to date, the 5,300 year-old Ötzi the Iceman, which was found in a Valentina Trujillon glacier in Austria. This mummy had an ear piercing 7–11 mm (1 to 000 gauge in American wire gauge) diameter. The oldest earrings found in a grave date to 2500 BC. These were located in the Sumerian city of Ur, home of the Biblical patriarch Abraham. Earrings are mentioned in the Bible. In Genesis 35:4, Jacob buries the earrings worn by members of his household along with their idols. In Exodus 32, Aaron makes the golden calf from melted earrings. Deuteronomy 15:12–17 dictates ear piercing for a slave who chooses not to be freed. Earrings are also referenced in connection to the Hindu goddess Lakshmi in the Vedas. Earrings for pierced ears were found in a grave in the Ukok region between Russia and China dated between 400 and 300 BC.

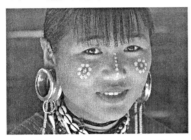

A Karen woman from Burma with traditional ear plugs

Among the Tlingit of the Pacific Northwest of America, earrings were a sign of nobility and wealth, as the placement of each earring on a child had to be purchased at an expensive potlatch. Earrings were common in the Eighteenth dynasty (1550–1292 BC.) of Egypt, generally taking the form of a dangling, gold hoop. Gem-studded, golden earrings shaped like asps seem to have been reserved for nobility. The ancient Greeks wore paste pendant earrings shaped like sacred birds or demigods, while the women of ancient Rome wore precious gemstones in their ears.

In Europe, earrings for women fell from fashion generally between the 4th and 16th centuries, as styles in clothing and hair tended to obscure the ears, but they gradually thereafter came back into vogue in Italy, Spain, England and France—spreading as well to North America—until the 1930s when the newly invented Clip-on earring came into vogue and eclipsed the custom of piercing. According to *The Anatomie of Abuses* by Philip Stubbs, earrings were even more common among men of the 16th century than women, while Raphael Holinshed in 1577 confirms the practice among "lusty courtiers" and "gentlemen of courage." Evidently originating in Spain, the practice of ear piercing among European men spread to the court of Henry III of France and then to Elizabethan era England, where earrings (typically worn in one ear only) were sported by such notables as Robert Carr, 1st Earl of Somerset, Shakespeare, Sir Walter Raleigh and Charles I of England. Common men wore earrings as well. From the European Middle Ages, a superstitious belief that piercing one ear improved long-distance vision led to the practice among sailors and explorers. Sailors also pierced their ears in the belief that their earrings could pay for a Christian burial if their bodies washed up on shore.

Nose piercing

Nose piercing also has a long history. Ca. 1500 BC., the Vedas refer to Lakshmi's nose piercings, but modern practice in India is believed to have spread from the Middle Eastern nomadic tribes by route of the Mughal emperors in the 16th century. It remains customary for Indian Hindu women of childbearing age to wear a nose stud, usually in the left nostril, due to the nostril's association with the female reproductive organs in Ayurvedic medicine. This piercing is sometimes done the night before the woman marries.

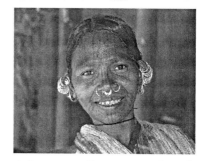

Indian woman with ear, septum and nostril piercings

In Genesis 24:22, Abraham's servant gave Rebbeca a nose ring. Nose piercing has been practiced by the Bedouin tribes of the Middle East and the Berber and Beja peoples of Africa, as well as Australian Aborigines. Many Native American and Alaskan tribes practiced septum piercing. It was popular among the Aztecs, the Mayans and the tribes of New Guinea, who adorned their pierced noses with bones and feathers to symbolize wealth and (among men) virility. The name of the Nez Perce tribe was derived from the practice, though nose piercing was not common within the tribe. The Aztecs, Mayans and Incas wore gold septum rings for adornment, with the practice continued to this day by the Kuna of Panama. Nose piercing also remains popular in Pakistan and Bangladesh and is practiced in a number of Middle Eastern and Arabic countries.

Piercings of the lip and tongue

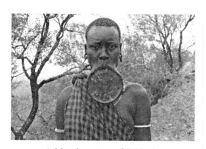

A Mursi woman of Ethiopia

Lip piercing and lip stretching were historically found in African and American tribal cultures. Labrets were sported by the Tlingit as well as peoples of Papua New Guinea and Amazonia. Aztecs and Mayans also wore labrets, while the Dogon people of Mali and the Nuba of Ethiopia wore rings. The practice of stretching the lips by piercing them and inserting plates or plugs was found throughout Pre-Columbian Mesoamerica and South America as well as among some of the tribes of the Pacific Northwest and Africa. In some parts of Malawi, it was quite common for women to adorn their lips with a lip disc called a "pelele" that by means of gradual enlargement from childhood could reach several inches of diameter and would eventually alter the occlusion of the jaw. Such lip stretching is still practiced in some places. Women of the Mursi of Ethiopia wear lip rings on occasion that may reach 15 centimetres (5.9 inches) in diameter.

In some Pre-Columbian and North American cultures, labrets were seen as a status symbol. They were the oldest form of high status symbol among the Haida women, though the practice of wearing them died out due to Western influence.

Tongue piercing was practiced by the Aztec, Olmec and Mayan cultures as a ritual symbol. Wall paintings highlight a ritual of the Mayans during which nobility would pierce their tongues with thorns, collecting the blood on bark which would be burned in honor of the Mayan gods. It was also practiced by the Haida, Kwakiutl and Tlingit, as well as the Fakirs and Sufis of the Middle East.

Nipple, navel and genital piercing

The history of nipple, navel and genital piercing has been particularly misrepresented as many of the myths promulgated by Malloy in the pamphlet *Body & Genital Piercing in Brief* continue to be reprinted. For instance, according to Malloy's colleague Jim Ward, Malloy claimed navel piercing was popular among ancient Egyptian aristocrats and was depicted in Egyptian statuary, a claim that is widely repeated. Other sources say there are no records to support an historical practice for navel piercing.

Navel piercing may have been practiced in Egypt, but its history is disputed.

However, records do exist that refer to practices of nipple and genital piercing in various cultures prior to the 20th century. *Kama Sutra*, dated to the Gupta Empire of Ancient India, describes genital piercing to permit sexual enhancement by inserting pins and other objects into the foreskin of the penis. The Dayak tribesmen of Borneo passed a shard of bone through their glans for the opposite reason, to diminish their sexual activity. In the Jewish Shabbat, there may be mention of a genital piercing in the probition against the *kamuz* in passage 24 (a), which medieval French Talmudic commenter Rashi interpreted as a chastity piercing for women. Other interpreters have, however, suggested that the *kumaz* was rather a pendant shaped like a vulva or a girdle.

Nipple piercing may have been a sign of masculinity for the soldiers of Rome. Nipple piercing has also been connected to rites of passage for both British and American sailors who had traveled beyond a significant latitude and longitude. Western women of the 14th century sometimes sported pierced as well as rouged nipples left visible by the low-cut dresses fashionable in the day. It is widely reported that in the 1890s, nipple rings called "bosom rings" resurfaced as a fashion statement among women of the West, who would wear them on one or both sides, but if such a trend existed, it was short-lived.

Growing popularity in the West

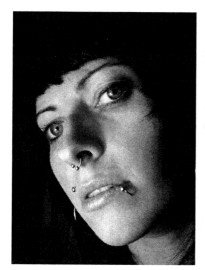

Woman with several facial piercings
(Monroe, Septum, and Lip)

By the early part of the 20th century, piercing of any body part had become uncommon in the West. After World War II, it began gathering steam among the gay male subculture. Even ear piercing for a time was culturally unacceptable for women, but that relatively common form of piercing began growing in popularity from the 1960s. In the 1970s, piercing began to expand, as the punk movement embraced it, featuring nontraditional adornment such as safety pins, and Fakir Musafar began popularizing it as a form of Modern Primitivism, which incorporated piercing elements from other cultures, such as stretching.

Body piercing was also heavily popularized in the United States by a group of Californians including Malloy and Ward, who is regarded as "the founding father of modern body piercing". In 1975, Ward opened a home-based piercing business in West Hollywood, which was followed in 1978 by the opening of Gauntlet Enterprises, "the first professional body piercing specialty studio in America." From it, Ward distributed the pamphlet which Malloy had written and Ward illustrated, disseminating much misinformation but stimulating interest in more exotic piercings. As word of body piercing spread to the wider community, Ward, Malloy and Musafar collaborated on launching the first publication dedicated to the subject, *PFIQ*.

A significant development in body piercing in England occurred in 1987, when during Operation Spanner, a group of homosexuals—including well known body piercer Alan Oversby—were convicted of assault for their involvement in consensual sadomasochism over a 10 year period, including acts of body piercing. The courts declared that decorative body piercing was not illegal, but that erotic body piercing *was*. Subsequently, the group Countdown on Spanner formed in 1992 in protest. The group appealed the decision before the High Court of Justice, the House of Lords and finally the European Commission of Human Rights, attempting to overturn the verdict which ruled consent immaterial in acts of sadomasochism, without success. In spite of their repeated failures, the situation publicized the issue, with *The Times* editorializing the court's decision as "illiberal nonsense" in 1993.

Body modification in general became more popular in the United States in the 1990s, as piercing also became more widespread, with growing availability and access to piercings of the navel, nose, eyebrows, lips, tongue, nipples and genitals. In 1993, a navel piercing was depicted in MTV Video Music Awards' "Music Video of the Year", "Cryin'," which inspired a plethora of young female fans to follow suit. According to 2009's *The Piercing Bible*, it was this consumer drive that "essentially

inspired the creation of body-piercing as a full-fledged industry." Body piercing was given another media-related boost in 2004, when during a Half-time performance at Super Bowl XXXVIII singer Janet Jackson experienced a "wardrobe malfunction" that left exposed Jackson's pierced nipple. Some professional body piercers reported considerable increases in business following the heavily publicized event.

21st century statistics

A 2005 survey of 10,503 people in England over the age of 16 found that approximately 10% (1,049) had body piercings in sites other than the earlobe, with a heavy representation of women aged 16–24 (46.2% piercing in that demographic). Among the most common body sites, the navel was top at 33%, with the nose and ear (other than lobe) following at 19% and 13%. The tongue and nipple tied at 9%. The eyebrow, lip and genitals were 8%, 4% and 2%, respectively. Preference among women followed closely on that ranking, though eyebrow piercings were more common than nipple piercings. Among male responders, the order was significantly different, descending in popularity from nipple, eyebrow, ear, tongue, nose, lip and genitals.

Reasons for piercing

A Hindu man in a religious procession with a trident piercing his cheeks

Reasons for piercing vary greatly. A 2001 survey in *Clinical Nursing Research*, an international publication, found that 62% of people who pierced had done so in an effort "to express their individuality." People also pierce to commemorate landmark events or to overcome traumatic ones. According to the assistant director of the Frankfurt University Teaching Hospital for Psychosomatic Medicine and Psychotherapy, some sexual abuse survivors choose body piercing as a means of "reclaiming body parts from memories of abuse". Piercing can also be chosen for simple aesthetic value, to highlight particular areas of the body, as a navel piercing may reflect a woman's satisfaction with the shape and condition of her stomach. Some people pierce, permanently or temporarily, to enhance sexual pleasure. Genital and nipple piercings may increase sexual satisfaction. Some people participate in a form of body play known as play piercing, in which piercings may be done temporarily on the genitals or elsewhere on the body for sexual gratification.

Piercing combined with suspension was historically important in the religious ceremonies of some Native Americans, featuring in many variants of the Sun Dance ceremony, including that practiced by the Crow Nation. During the Crow ceremony, men who wished to obtain visions were pierced in the

shoulders or chest by men who had undergone the ceremony in the past and then suspended by these piercings from poles in or outside of the Sun Dance Lodge. Some contemporary Southeast Asian rituals also practice body piercing, as a form of spiritual self-mortification. Generally, the subject attempts to enter an analgesic trance prior to the piercing.

Bridging the gap between self-expressive piercing and spiritual piercing, modern primitives use piercing and other forms of body modification as a way of ritually reconnecting with themselves and society, which according to Musafar once used piercing as a culturally binding ritual. But at the same time that piercing can be culturally binding, it may also be a means of rebellion, particularly for adolescents in Western cultures.

Piercing prohibitions and taboos

While body piercing has grown more widespread, it can remain controversial, particularly in youth. In 2004, controversy erupted in Crothersville, Indiana when a local high school featured a spread on "Body Decorations" in its yearbook that featured tattoos and body piercings of teachers and students. That same year, in Henry County, Georgia, a 15-year-old boy remained in in-school suspension for a full month for violating school policy by wearing eyebrow, nose, labret and tongue piercings to school before his mother decided to homeschool him. According to 2006's *Tattoos and Body Piercing*, corporate dress codes can also strictly limit piercing displays. At that time, Starbucks limited piercings to two per ear and jewellery to small, matched earrings. Employees of Walt Disney Parks and Resorts were not permitted to display piercings at all.

Body piercing in some religions is held to be destructive to the body. Some passages of the Bible, including Leviticus 19:28, have been interpreted as prohibiting body modification because the body is held to be the property of God. The Church of Jesus Christ of Latter-day Saints has taken an official position against most piercings unless for medical reasons, although they accept piercings for women as long as there is only one set of piercings in the lower lobe of the ears and no other place on the body. Wearing of nose rings on *Shabbat* is forbidden by the Talmud.

World records

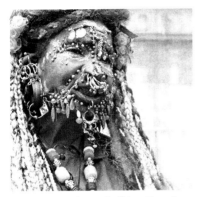

Elaine Davidson, the "Most Pierced Woman" in the world as of 2009

Officially titled "Most Pierced Woman", Elaine Davidson of Scotland holds the Guinness World Record for most permanent piercings, first setting this record in 2000 upon verification by Guinness judges of 462 body piercings, with 192 at the time being around her head and face. As of 8 June 2006, her Guinness-certified piercings numbered 4,225. In February 2009, *The Daily Telegraph* reported that she had 6,005. The "Most Pierced Man" as of 2009 was Luis Antonio Agüero, who had 230 permanent piercings, with 175 rings adorning his face alone.

In January 2003, Canadian Brent Moffat set the World Record for most body piercings in one session (700 piercings with 18g surgical needles in 1 session of 7 hours, using play piercing where the skin is pierced and sometimes jewellery is inserted, which is worn temporarily). In December of the same year, Moffat had 900 piercings in 4½ hours. On 4 March 2006, the record was overturned by Kam Ma, who had 1,015 temporary metal rings inserted in 7 hours and 55 minutes. The record for most body piercings with surgical needles was set on 29 May 2008, when Robert Jesus Rubio allowed 900 18-gauge, 0.5 centimetres (0.2 in)-long surgical needles to be inserted into his body.

Contemporary piercing practises

Contemporary body piercing jewellery

Body piercing jewellery should be hypoallergenic. A number of materials are used, with varying strengths and weaknesses. Surgical stainless steel, niobium and titanium are commonly used metals, with titanium the least likely to cause allergic reaction of the three. Platinum and palladium are also safe alternatives, even in fresh piercings. Initial piercings should never be done with gold of any grade, as gold is mixed with other metals, and sterling silver is not a good alternative in a piercing, as it may cause allergies in initial piercings and will tarnish in piercings of any age. An additional risk for allergic reaction may arise when the stud or clasp of jewellery is made from a different metal than the primary piece.

Body piercing jewellery is measured by thickness and diameter/length. Most countries use millimeters. In the USA, the Brown & Sharpe AWG gauging system is used, which assigns lower numbers to thicker middles. 00 gauge is 9.246 millimetres (0.364 in), while 20 gauge is 0.813 millimetres (0.032 in).

Piercing tools

Permanent body piercings are performed by creating an opening in the body using a sharp object through the area to be pierced. This can either be done by puncturing an opening using a needle (usually a hollow medical needle) or scalpel or by removing tissue, either with a dermal punch or through scalpelling.

Tools used in body piercing include:

The piercing needle

> The standard method in the United States involves making an opening using a beveled-tip hollow medical needle, which is available in different lengths, gauges and even shapes. While straight needles are useful for many body parts, curved needles are manufactured for areas where straight needles are not ideal. The needle selected is typically the same gauge (or sometimes larger as with cartilage piercings) as the initial jewellery to be worn, with higher gauges indicating thinner needles. The needle is inserted into the body part being pierced, frequently by hand but sometimes with the aid of a needle holder or pusher. While the needle is still in the body, the initial jewellery to be worn in the piercing is pushed through the opening, following the back of the needle. Jewellery is often inserted into the hollow end of a needle, so that as the needle pulls through the jewellery is left behind.

The indwelling cannula

> Outside of the United States, many piercers use a needle containing a cannula (or catheter), a hollow plastic tube placed at the end of the needle. In some countries, the piercing needle favoured in the United States is regarded as a medical device and is illegal for body piercers. The procedure is similar to the piercing needle method, but the initial jewellery is inserted into the back of the cannula and the cannula and the jewellery are then pulled through the piercing. More bleeding may follow, as the piercing is larger than the jewellery.

The dermal punch

> A dermal punch is used to remove a circular area of tissue, into which jewellery is placed, and may be useful for larger cartilage piercings. They are popular for use in ears, though not legal for use by nonmedical personnel in some parts of the United States.

The piercing gun

Piercing guns, which were originally developed for tagging livestock, are typically used for ear piercing, but may be used for other body parts as well. Piercing guns are generally not favoured by professional body piercers. Guns use relatively blunt, solid studs that punch through tissue; thus they cause more trauma to tissue than proper piercing needles, which are sharp and hollow and remove tissue cleanly rather than crush it. They are also considered unsuitable for hygienic reasons. Piercing with a piercing gun causes microsprays of plasma and blood; the guns frequently contain plastic components which are unable to be cleaned in an autoclave system, while surface cleansers

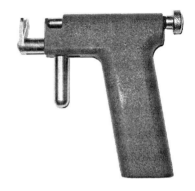

Piercing guns, like this one with its plastic, non-autoclavable handle, are not professionally favored or recommended, even for ears.

do not kill all bacteria. Piercing guns are frequently encountered in retail outlets, where those wielding them may be inadequately trained. The Association of Professional Piercers recommends that piercing guns not be used for any piercing, including ears.

Cork

Cork may be placed on the opposite side of the body part being pierced to receive the needle.

Forceps

Forceps, or clamps, may be used to hold and stabilize the tissue to be pierced. Most piercings that are stabilized with forceps use the triangular-headed "Pennington" forcep, while tongues are usually stabilized with an oval-headed forcep. Most forceps have large enough openings in their jaws to permit the needle and jewellery to pass directly through, though some slotted forceps are designed with a removable segment instead for removal after the piercing. Forceps are not used in the freehand method, in which the piercer supports the tissue by hand.

Needle receiving tubes

A hollow tube made of metal, shatter-resistant glass or plastic, needle receiving tubes, like forceps, are used to support the tissue at the piercing site and are common in septum and some cartilage piercings. Not only are these tubes intended to support the tissue, but they also receive the needle once it has passed through the tissue, offering protection from the sharp point. Needle receiving tubes are not used in the freehand piercing method.

Anaesthesia

Anaesthesia is supplied by some piercers, particularly in the United Kingdom and Europe. The anaesthesia may be topical or injected. Piercers and other non-medical personnel are not legally permitted to administer anaesthetics in the United States.

Risks associated with body piercing

Body piercing is an invasive procedure with risks. In a 2005 survey of 10,503 persons over the age of 16 in England, complications were reported in 31% of piercings, with professional help being necessary in 15.2%. 0.9% had complications serious enough to require hospitalization.

Some risks of note include:

Autoclaves such as this one are standard equipment in professional piercing studios, helping to prevent infection.

- Allergic reaction to the metal in the piercing jewellery, particularly nickel. This risk can be minimized by using high quality jewellery manufactured from Titanium or Niobium or similar inert metals.

- Infection, bacterial or viral, particularly from *Staphylococcus aureus*, *group A streptococcus* and *Pseudomonas spp.* Reports at the 16th European Congress of Clinical Microbiology and Infectious Diseases in 2006 indicated that bacterial infections are seldom serious, but that between 10–20% of piercings result in local benign bacterial infection. The Mayo Clinic estimates 30%. Risk of infection is greatest among those with congenital heart disease, who have a much higher chance of developing life-threatening infective endocarditis, hemophiliacs and diabetics, as well as those taking Corticosteroids. In 2006, a diabetic woman in Indiana lost a breast due to an infection from a nipple piercing. Viral infections may include hepatitis B, hepatitis C and, potentially, HIV, although as of 2009 there had been no documented cases of HIV caused by piercing. While rare, infection due to piercing of the tongue can be fatal.

- Excess scar tissue, including keloid formation. While piercings can be removed, they may leave a hole, mark or scar.

- Physical trauma including tearing, friction or bumping of the piercing site, which may cause edema and delay healing. The risks can be minimized by wearing properly sized jewellery and not changing it unnecessarily, by not touching the piercing more than required for aftercare, and by being conscious of environmental factors (such as clothing) that may impact the piercing.

- Oral trauma, including recession of gingival tissue and dental fracture and wear. Recession of gingival tissue affects 19% to 68% of subjects with lip and/or intra-oral ornaments. In some cases, the alveolar tooth-bearing bone is also involved, jeopardizing the stability and durability of the teeth in place and requiring a periodontal regeneration surgery. Dental fracture and wear affects 14% to 41% of subjects with lip and/or intra-oral ornaments.

Contemporary body piercing studios generally take numerous precautions to protect the health of the person being pierced and the piercer. Piercers are expected to sanitize the location to be pierced as well as their hands, even though they will often wear gloves during the procedure (and in some areas must, as it is prescribed by law). Quite frequently, these gloves will be changed multiple times, often one pair

for each step of setup to avoid cross contamination. For example, after a piercer has cleaned the area to be pierced on a client, the piercer may change gloves to avoid recontaminating the area with the gloves he/she used to clean it. Tools and jewellery should be sterilized in autoclaves, and non-autoclavable surfaces should be cleaned with disinfectant agents on a regular basis and between clients.

In addition, the Association of Professional Piercers recommends a class in blood-borne pathogens as part of professional training.

The healing process and body piercing aftercare

The aftercare process for body piercing has evolved gradually through practise, and many myths and harmful recommendations persist. A reputable piercing studio should provide clients with written and verbal aftercare instructions, as is in some areas mandated by law.

The healing process of piercings is broken down into three stages:

- *The inflammatory phase*, during which the wound is open and bleeding, inflammation and tenderness are all to be expected;
- *The growth or proliferative phase*, during which the body produces cells and protein to heal the puncture and the edges contract around the piercing, forming a tunnel of scar tissue called a fistula. This phase may last weeks, months, or longer than a year.
- *The maturation or remodeling phase*, as the cells lining the piercing strengthen and stabilize. This stage takes months or years to complete.

It is normal for a white or slightly yellow discharge to be noticeable on the jewellery, as the Sebaceous glands produce an oily substance meant to protect and moisturize the wound. While these sebum deposits may be expected for some time, only a small amount of pus, which is a sign of inflammation or infection, should be expected, and only within the initial phase. While sometimes difficult to distinguish, sebum is "more solid and cheeselike and has a distinctive rotten odor", according to *The Piercing Bible*.

The amount of time it typically takes a piercing to heal varies widely according to the placement of the piercing. Genital piercings can be among the quicker to heal, with piercings of the clitoral hood and Prince Albert piercings healing in as little as a month, though some may take longer. Navel piercings can be the slowest to heal, with one source reporting a range of six months to two full years. The prolonged healing of navel piercings may be connected to clothing friction.

Related media

- A chart comparing wire gauges likely to be encountered when making jewellery
- A chart comparing O-ring sizes (Aerospace Specification series numbering) to American gauge jewellery

External links

- American Association of Professional Piercers' website [1]

The Tattoo Artist

Tattoo artist

A **tattoo artist** (also **tattooer** or **tattooist**) is an individual who applies permanent decorative tattoos, often in an established business called a **tattoo shop**, **tattoo studio** or **tattoo parlour**. Tattooists usually learn their craft via an apprenticeship under a trained & experienced mentor.

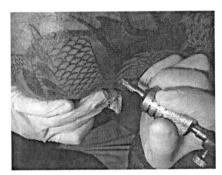

A tattoo artist performs a tattoo.

Apprenticeships

To become a tattoo artist a person must first have a passion for art and for drawing and also be able to draw. Then the next step is to gain an apprenticeship from a person that is already skilled in the art of tattooing.

Tattooist Artwork

Tattooers may use flash (pre-drawn, stock images that can be traced onto the skin) or create original tattoos for their customers.

Tattooist Tools

Some of the tools of the trade have greatly evolved, and some have stayed the same. Such as the tattoo machine. In itself the machine has not changed from its original design and concept. A tattoo artist can also have many different needle sets. Such as round liner needles, round shader needles, flat shaders, and mag needles. The amount of needles attached to the needle bar change as well. There are large magnum needle groups from 15 needles on one bar, all the way to 55 needles on one bar. A tattoo artist must have the basic tools in order to provide a tattoo. All other items at the artist's disposal are as different as each tattoo. Basic tools are the tattoo machine, power supply, clip cord, foot pedal, grip, tips, grip stem, needles, and tattoo ink.

Tattoo studios

The properly equipped tattoo studio will use biohazard containers for objects that have come into contact with blood or bodily fluids, sharps containers for old needles, and an autoclave for sterilizing tools. Certain jurisdictions also require studios by law to have a sink in the work area supplied with both hot and cold water.

Proper hygiene requires a body modification artist to wash his or her hands before starting to prepare a client for the stencil, between clients, after a tattoo has been completed, and at any other time where cross contamination can occur. The use of single use disposable gloves is also mandatory. In some

Tattoo artist Kevin Black wearing latex gloves while using his tattoo machine (a.k.a. "tattoo gun").

countries and U.S. states it is illegal to tattoo a minor even with parental consent, and it is usually not allowed to tattoo impaired persons (e.g. someone intoxicated or under the influence of drugs), people with contraindicated skin conditions, those who are pregnant or nursing, or those incapable of consent due to mental incapacity. Before the tattooing begins the client is asked to approve the position of the applied stencil. After approval is given the artist will open new, sterile needle packages in front of the client, and always use new, sterile or sterile disposable instruments and supplies, and fresh ink for each session (loaded into disposable ink caps which are discarded after each client). Also, all areas which may be touched with contaminated gloves will be wrapped in clear plastic to prevent cross-contamination. Equipment that cannot be autoclaved (such as countertops, machines, and furniture) will be wiped with an approved disinfectant.

The local health department can/will do a hands on inspection of tattoo studios every 4 months in the state of Tennessee. The venue will be graded based on the areas being inspected. If the studio passed an inspection, the health department will sign off on a passing scorecard and the studio will be required to show their score publicly. If the studio fails an inspection, they will be given the opportunity to correct the mistakes (if minor) or be fined (major health risks)and can also be placed out of business on the spot.

Also, the possession of a working autoclave is mandatory in most states. An autoclave is a medical sterilization device used to sterilize stainless steel. The autoclave itself will be inspected by the health department and required to submit weekly spore tests.

Membership in professional organizations, or certificates of appreciation/achievement, generally helps artists to be aware of the latest trends. However, many of the most notable tattooists do not belong to any association. While specific requirements to become a tattooist vary between jurisdictions, many mandate only formal training in bloodborne pathogens, and cross contamination. The local department of health regulates tattoo studios in many jurisdictions.

For example, according to the health departments in Oregon and Hawaii, tattoo artists in these states are required to take and pass a test ascertaining their knowledge of health and safety precautions, as well as the current state regulations. Performing a tattoo in Oregon state without a proper and current license or in an unlicensed facility is considered a felony offense. Tattooing was legalized in New York City, Massachusetts, and Oklahoma between 2002 and 2006.

See also

• List of tattoo artists

Tattoo machine

A **tattoo machine** is a hand-held device generally used to create a tattoo, a permanent marking of the skin with indelible ink. Modern tattoo machines use alternating electromagnetic coils to move a needle bar up and down, driving pigment into the skin. Tattoo artists generally use the term "machine", or even "iron", to refer to their equipment.

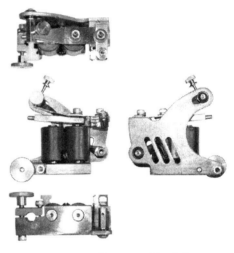

Traditional 2 coil tattoo machine 4 views

History

The first tattoo gun to be discovered was by a Danish inventor named Oersted in 1819 and it was battery operated.http:/ / www. tattooarchive. com/ history/ tattoo_machine. htm Thomas Edison brought the patent to America from Oersted. The basic machine was invented by Thomas Alva Edison and patented as the 'Electric pen' or 'Stencil pen' in Newark, New Jersey, United States in 1876. It was originally intended to be used as an engraving device, but in 1891, Samuel O'Reilly discovered that Edison's machine could be modified and used to introduce ink into the skin, and later patented a tube and needle system to provide an ink reservoir.

The technology used to make modern tattoo machines has come a long way, however. While O'Reilly's machine was based on the rotary technology of Edison's engraving device, modern tattoo machines use electromagnets. The first machine based on this technology was a single coil machine patented by Thomas Riley of London, just twenty days after O'Reilly filed the patent for his rotary machine. For his machine, Riley placed a modified door bell assembly in a brass box. The modern two coil configuration was patented by Alfred Charles South,

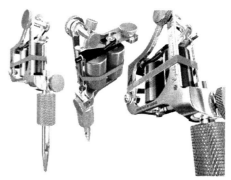

2 coil tattoo machine perspective view

also of London. Because it was so heavy, a spring was often attached to the top of the machine and the ceiling to take most of the weight off the operator's hand.

Most modern tattoo machines can control needle depth, speed, and force of application, which has allowed tattooing to become a very precise art form. Such advancements in precision have also produced a style of facial tattooing that has attained mainstream popularity in America called dermapigmentation, or "permanent cosmetics".

From **"Basic Fundamentals of Modern Tattoo"**

The basis of the modern tattoo machine is still relatively unchanged from the 1820 discovery by a Danish inventor Hans Christian Oersted called electromagnetism (Brian & Cohen 2007). Oersted's invention is now known, in what is commonly implemented as a prime motor for the doorbell circuit, as the basis for all modern coil tattoo systems. Modern tattoo is symbolized by the advent of the mechanized version of the emplacement of some form of ink or dye under the skin. The basic usage was first transposed from an invention patented in 1876 by Thomas Edison (U.S. Patent 196,747). Edison's machine was not intended for the skin, but for creating embroidery patterns by means of an electric punch. This concept was further elaborated on in 1891 by Samuel O'Reilly, who took a modified version of Edison's now dual coiled mechanism and deemed it proper for skin tattooing (U.S. Patent 196,747). It is argued that O'Reilly was the inventor, even though it is actually Charlie Wagner who holds the 1904 patent for the "tattoo machine" (www.tattooarchive.com). This patent demonstrates that the "tattoo device" has an ink chamber or "tube" and uses the single coil method for movement of the armature bar. In 1929 Percy Waters received his patent for the dual coil tattoo machine, which was set in a frame (U.S. Patent 1724812). Another patent was issued in 1979 to Carol Nightengale, who made some substantial modifications to the frame (U.S. Patent #4159659). Some of Nightengale's modifications can be seen today in cutback machines, and fully adjustable frame styles. Nightengale's version was also the first patented design that utilized front and

rear spring apertures. While the history of the modern machine appears just as obscure as that of the history of the ancient process of tattoo, it is obvious that there were many individuals working toward the same concept. Even today there are many innovations such as the "swash drive" or bearing driven rotary machine, the "neuma" which is run off air compression and cuts the coils and electromagnetism completely out of the machine, and the contactless machines which avoid the use of spark and utilize vibration to move the armature bars. Advances in coils from 6 to 16 wraps are also available. Tattoo machines have evolved in many ways, but the primary goal has remained the same over the ages; to put ink into the skin. The speed and accuracy that this is achieved has evolved over time, and the inks and pigments used have also changed. There are many exciting things being developed and with the information age of the Internet being upon us currently, the knowledge of machine builders and the number of tools available to tattoo artists around the world is expanding at an exponential speed. Even with all these advancements in the tattoo world, it is not uncommon to still see tattoo rituals performed in places like Japan and American Samoa the same way that they have been done for centuries.

Classification

Functionally speaking there are liner tattoo machine and shader tattoo machine. Mechanically speaking, there are coil tattoo machines and rotary tattoo machines.

- Rotary tattoo machine: the original type, based on rotary technology, which was invented by Samuel O'Reilly and was improved by the fellow tattoo artists through the years. The rotary tattoo machines were considered to be less effective than the coil machines until recent technologies which put rotary tattoo machines in the hands of many professional artists today.
- Coil tattoo machine: the modern type, based on electromagnetic technology, which was known for many years to be significantly more effective form of tattooing than the rotary tattoo machine until recently.
- Liner tattoo machine: the purpose of a liner machine is to draw the outlines of the tattoo; normally there are eight wrap coils in the motor.
- Shader tattoo machine: the shader machine is to fill out the tattoo with different colors; compared with the liner machine, shader requires a stronger power supply, and it normally has 10 wrap coils in the motor.

Tattoo ink

Tattoo inks consist of pigments combined with a carrier, and are used in tattooing.

Tattoo inks are available in a range of colors that can be thinned or mixed together to produce other colors and shades. Most professional tattoo artists purchase inks pre-made (known as pre-dispersed inks), while some tattooers mix their own using a dry pigment and a carrier.

Tattoo ink is generally permanent. Tattoo removal is difficult, painful, and degree of success depends on the materials used. A recently developed ink InfinitInk is comparatively easy to remove. Unsubstantiated claims have been made that some inks fade over time, yielding a "semi-permanent tattoo."

Ingredients

Regulations

In the United States, tattoo inks are classified as a cosmetic or color additive, and is thus subject to regulation by the U.S. Food and Drug Administration (FDA); Some tattoo parlors have incorrectly claimed that their inks have such an approval. Although the pigments are not regulated, the FDA and medical practitioners have noted that many ink pigments used in tattoos are "industrial strength colors suitable for printers' ink or automobile paint."

In California, Proposition 65 requires that Californians be warned before exposure to certain harmful chemicals; tattoo parlors in California must warn their patrons that tattoo inks contain heavy metals known to cause cancer, birth defects, and other reproductive harm.

Pigment bases

Manufacturers are not required to reveal their ingredients or conduct trials, and recipes may be proprietary. Professional inks may be made from iron oxides (rust), metal salts, plastics. Homemade or traditional tattoo inks may be made from pen ink, soot, dirt, blood, or other ingredients.

Heavy metals used for colors include mercury (red); lead (yellow, green, white); cadmium (red, orange, yellow); nickel (black); zinc (yellow, white); chromium (green); cobalt (blue); aluminium (green, violet); titanium (white); copper (blue, green); iron (brown, red, black); and barium (white). Metal oxides used include ferrocyanide and ferricyanide (yellow, red, green, blue). Organic chemicals used include azo-chemicals (orange, brown, yellow, green, violet) and naptha-derived chemicals (red). Carbon (soot or ash) is also used for black. Other compounds used as pigments include antimony, arsenic, beryllium, calcium, lithium, selenium, and sulphur.

Tattoo ink manufacturers typically blend the heavy metal pigments and/or use lightening agents (such as lead or titanium) to reduce production costs.

Carriers

A *carrier* acts as a solvent for the pigment, to "carry" the pigment from the point of needle trauma to the surrounding dermis. Carriers keep the ink evenly mixed and free from pathogens, and aid application. The most typical solvent is ethyl alcohol or water, but denatured alcohols, methanol, rubbing alcohol, propylene glycol, and glycerine are also used. When an alcohol is used as part of the carrier base in tattoo ink or to disinfect the skin before application of the tattoo, it increases the skin's permeability, helping to transport more chemicals into the bloodstream.

Health concerns

Main article: Tattoo medical issues

A variety of medical problems, though uncommon, can result from tattooing.

Medical workers have observed rare but severe medical complications from tattoo pigments in the body, and have noted that people acquiring tattoos rarely assess health risks *prior* to receiving their tattoos.

Aging

Inks that react with light can lead to fading. To Prevent aging of a tattoo its always important to apply sun screen if the tattoo is visible to the sun. This way the ink can stay darker instead of starting to lose its deep coloring. It is also very important to stay away from strong UV radiation, like that of a tanning bed. Exposure to UV rays will damage and fade any tattoo.

Other tattoo inks

Glow in the dark ink and blacklight ink

Both blacklight and glow in the dark inks have been used for tattooing. Glow in the dark ink absorbs and retains light, and then glows in darkened conditions by process of phosphorescence. Blacklight ink does not glow in the dark, but reacts to non-visible UV light, producing a visible glow by florescence. The resulting glow of both these inks is highly variable. The safety of such inks for use on humans is widely debated in the tattoo community.

The ingredients in Crazy Chameleon & Wizard brand Blacklight ink (2 brands of blacklight ink) are listed as: (PMMA) Polymethylmethacrylate 97.5% and microspheres of fluorescent dye 2.5% suspended in UV sterilized, distilled water.

Removable tattoo ink

Main article: InfinitInk

While tattoo ink is in generally very painful and laborious to remove, tattoo removal being quite involved, a recently introduced ink called InfinitInk has been developed to be easier to remove by laser treatments than traditional inks.

Black henna

Health Canada has advised against the use of "black henna" temporary tattoo ink which contains para-phenylenediamine (PPD), an ingredient in hair dyes. Black henna is normally applied externally in temporary Mehandi applications, rather than being inserted beneath the skin in a permanent tattoo.

Allergic reactions to PPD include rashes, contact dermatitis, itching, blisters, open sores, scarring and other potentially harmful effects.[1]

Ancient Roman recipe

The Roman physician Aetius created a recipe for tattoo ink. [2]

One pound of Egyptian pine bark

Two ounces of corroded bronze, ground with vinegar

Two ounces of gall (insect egg deposits)

One ounce of vitriol (iron sulphate)

Mix well and sift. Soak powder in 2 parts water and 1 part leek juice. Wash the skin to be tattooed with leek juice. Prick design with needles until blood is drawn. Rub in the ink.

References

- Health Canada website [1]
- About.com article on tattoo inks [3]

Tattoo studio

A **tattoo studio** (also **tattoo shop, tattoo parlor, tattoo parlour**) is a place where people receive permanent decorative tattoos from a tattoo artist.

The properly equipped tattoo studio will use biohazard containers for objects that have come into contact with blood or bodily fluids, sharps containers for old needles, and an autoclave for sterilizing tools. Certain jurisdictions also require studios by law to have a sink in the work area supplied with both hot and cold water.

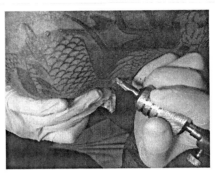

A tattoo artist performs a tattoo.

Proper hygiene requires a body modification artist to wash his or her hands before starting to prepare a client for the stencil, between clients, and at any other time where cross contamination can occur. The use of single use disposable gloves is also mandatory. In some states and countries it is illegal to tattoo a minor even with parental consent, and it is usually not allowed to tattoo impaired persons, people with contraindicated skin conditions, those who are pregnant or nursing, or those incapable of consent due to mental incapacity. Before the tattooing begins the client is asked to approve the position of the applied stencil. After approval is given the artist will open new, sterile needle packages in front of the client, and always use new, sterile or sterile disposable instruments and supplies, and fresh ink for each session (loaded into disposable ink caps which are discarded after each client). Also, all areas which may be touched with contaminated gloves will be wrapped in clear plastic to prevent cross-contamination. Equipment that cannot be autoclaved (such as countertops, machines, and furniture) will be wiped with an approved disinfectant.

Membership in professional organizations, or certificates of appreciation/achievement, generally helps artists to be aware of the latest trends. However, many of the most notable tattooists do not belong to any association. While specific requirements to become a tattooist vary between jurisdictions, many mandate only formal training in bloodborne pathogens, and cross contamination. The local department of health regulates tattoo studios in many jurisdictions.

For example, according to the health department in Oregon and Hawaii, tattoo artists in these states are required to take and pass a test ascertaining their knowledge of health and safety precautions, as well as the current state regulations. Performing a tattoo in Oregon state without a proper and current license or in an unlicensed facility is considered a felony offense. Tattooing was legalized in New York City, Massachusetts, and Oklahoma between 2002 and 2006.

Tattooers may use flash (pre-drawn, stock images that can be traced onto the skin) or create original tattoos for their customers.

Types of Tattoos

Body art

Body art is art made on, with, or consisting of, the human body. The most common forms of body art are tattoos and body piercings, but other types include scarification, branding, scalpelling, shaping (for example tight-lacing of corsets), full body tattoo and body painting.

More extreme body art can involve things such as mutilation or pushing the body to its physical limits. For example, one of Marina Abramović's works involved dancing until she collapsed from exhaustion, while one of Dennis Oppenheim's better-known works saw him lying in the sunlight with a book on his chest, until his skin, excluding that covered by the book, was badly sunburned. It can even consist of the arrangement and dissection of preserved bodies in an artistic fashion, as in the case of the plastinated bodies used in the travelling Body Worlds exhibit.

Complex Kadakali makeup is a form of body art

Body art is also a sub-category of performance art, in which artists use or abuse their own body to make their particular statements.

In more recent times, body became a subject of much broader discussions and treatments that cannot be reduced to the body art in its common understanding. Important strategies that question the human body are: implants, body in symbiosis with the new technologies, virtual body etc. Scientific research in this area, for example that by Kevin Warwick, can be considered in this artistic vein. A special case of the body art strategies is the absence of body. The most important artists that performed the "absence" of body through their artworks were: Keith Arnatt, Andy Warhol, Anthony Gormley and Davor Džalto.

Examples of body art

Vito Acconci once documented, through photos and text, his daily exercise routine of stepping on and off a chair for as long as possible over several months. Acconci also performed a 'Following Piece', in which he followed randomly chosen New Yorkers.

The Vienna Action Group was formed in 1965 by Herman Nitsch, Otto Muhl, Gunter Brus and Rudolf Schwartzkogler. They performed several body art actions, usually involving social taboos (such as genital mutilation).

In France, Body Art appeared as "Art Coporel" with artists such as Michel Journiac and Gina Pane.

In Italy in the 1970s one the famous artist in the movement was Ketty La Rocca.

Marina Abramovic performed 'Rhythm O' in 1974. In the piece, the audience was given instructions to use on Abramovic's body an array of 72 provided instruments of pain and pleasure, including knives, feathers, and a loaded pistol. Audience members cut her, pressed thorns into her belly, put lipstick on her, and removed her clothes. The performance ended after six hours when someone held the loaded gun up to Abramovic's head and a scuffle broke out.

The movement gradually evolved to the works more directed in the personal mythologies, as at Jana Sterbak, Rebecca Horn, Youri Messen-Jaschin or Javier Perez.

Jake Lloyd Jones a Sydney based artist conceived a body art ride which has become an annual event, participants are painted to form a living rainbow that rides to the Pacific Ocean and immerses itself in the waves, Sydney Body Art Ride

Gallery

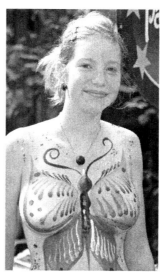

Butterfly (2007)

See also

- Body painting
- Body modification

External links

- Body art [1] at the Open Directory Project
- Australian Museum's Body Art section [2]
- National Institute for Occupational Safety and Health - Body Art Page [4]

Permanent makeup

Permanent makeup is a cosmetic technique which employs tattoos (permanent pigmentation of the dermis) as a means of producing designs that resemble makeup, such as eyelining and other permanent enhancing colors to the skin of the face, lips, and eyelids. It is also used to produce artificial eyebrows, particularly in people who have lost them as a consequence of old age, disease, such as alopecia, chemotherapy, or a genetic disturbance, and to disguise scars and white spots in the skin such as in vitiligo. It is also used to restore or enhance the breast's areola, such as after breast surgery.

Most commonly called **permanent cosmetics**, other names include **dermapigmentation**, **micropigmentation**, and **cosmetic tattooing**, the latter being most appropriate since permanent makeup is, in fact, tattooing. In the United States and other countries, the inks used in permanent makeup and the pigments in these inks are subject to FDA or similar agency regulation as cosmetics and color additives.

Regulations and oversight

Permanent makeup regulations vary from country to country: sometimes by state, province, county or even city to city. For instance, in the US, while in most areas it falls under the cognizance of the Department of Health, State Boards of Cosmetology are often the oversight agency. In fact, in some areas a cosmetology or esthetics license is required, while in other areas, cosmetologists are prohibited from conducting these procedures. Exclusive to Australia, practitioners are prohibited from advertising the procedures as "permanent" since it is commonly known that tattoos will fade over time and it is their opinion that the "...benefits of cosmetic tattooing are not permanent and will generally only last three to five years." The purpose of the ACCC action was to alert the consumer public to the fact that touch ups may be required to maintain optimal appearance. Some believe this position is not consistent with the fact that permanent makeup is tattooing and tattooing is a permanent process..

Before undergoing any form of cosmetic tattooing, it is essential to ensure that a salon has appropriate approvals from their local health authorities for skin penetration procedures. It is important to note that just because a salon has local health approvals for general beauty therapy services does not necessarily mean that they have approval for cosmetic tattooing procedures, it is prudent to insist on seeing the certificate of registration.

Mobile tattooing (in home) services may be a breach of Health Guidelines in some locations, for example in Melbourne Australia they prohibit mobile tattooing services .

History

Permanent makeup dates back at least to the start of the 20th century, though its nature was often concealed in its early days. The tattooist George Burchett, a major developer of the technique when it become fashionable in the 1930s, described in his memoirs how beauty salons tattooed many women without their knowledge, offering it as a "complexion treatment ... of injecting vegetable dyes under the top layer of the skin."

Immediate Results

Permanent makeup results in enhanced features of the face -- definition is rendered to eyebrows, eyes and lips by the use of colors. Results can imitate topically applied cosmetics or can be quite unnoticeable, depending upon the design, color value and amount of pigment used.

At first, permanent makeup results may look harsh. This is due to color remaining in the outermost epidermal layers of skin at the start. Color softens within a few days during the healing process as the upper layers of epidermis slough and are replaced by new epidermal cells.

Long Term Results

The best possible color results can perform for many years or may begin to fade over time. How much time is individual per person. While permanent makeup pigment remains in the dermis its beauty-span may be influenced by several possible factors. These can be environmental, procedural and/or individual factors . Sun exposure fades color. The amount and color of pigment deposit at the dermal level can affect the length of time that permanent makeup looks its best. Very natural looking applications are likely to require a touch-up before more dramatic ones for this reason. Individual influences include lifetyles that find an individual in the sun regularly such as with gardening or swimming. Skin tones are a factor in color value changes over time.

Imperfections

Permanent makeup is a welcome enhancement for most recipients. There are cases, however, of undesired results. The 4 most common complaints are "too dark," "wrong color," "uneven" and "too big." A skilled, experienced, permanent makeup professional is able to adjust the color and evenness of permanent makeup results in most cases. A design that is too large presents a serious challenge, however. Costly pigment lightening techniques and/or removal may be the only solutions.

However, before embarking on the aforementioned removal/correction procedures, it should also be noted that you still have the option of applying conventional makeup to correct any imperfections or to further enhance the overall effect.

Removal

See also: Tattoo removal

As with tattoos, permanent makeup can be difficult to remove. Common techniques used for this are laser resurfacing, dermabrasion (physical or chemical exfoliation), and surgical removal. Camouflaging—adding a new pigment which counteracts the tattoo color and attempts to emulate normal skin color is considered a poor choice by professionals. Removal is more painful and laborious than the tattooing itself.

Adverse effects and complications

See also: Tattoo health risks

As with tattoos, permanent makeup may have complications, such as allergies to the pigments, formation of scars, granulomas and keloids, skin cracking, peeling, blistering and local infection. The use of unsterilized tattooing instruments may infect the patient with serious diseases such as HIV and hepatitis. Removal problems may also ensue, due to patient dissatisfaction or regret, and they may be particularly difficult to remove in places such as eyelids and lips without leaving permanent sequelae.

On very rare occasion, people with permanent makeup have reported swelling or burning in the affected areas when they underwent magnetic resonance imaging (MRI).

Examples

This client had her eyebrows and top eyeliner permanently tattooed. The eyebrow tattooing is an example of a "powdery filled" technique as opposed to individual hairline strokes since the client already has eyebrow hair but simply wanted an enhancement and shaping. The top eyeliner represents a thin eyeliner tattoo and a "lash enhancement" procedure that is used to define the eye without making it look excessively made up.

External links

- FDA: Tattoos and Permanent Makeup [5]
- FDA: Think Before You Ink - Are Tattoos Safe? [1]
- Society of Permanent Cosmetic Professionals [2]
- American Academy of Micropigmentation [3]
- International Micropigmentation Association [4]
- FDA: Tattoo Pigment Recalls [5]

Medical tattoo

A **medical tattoo** is a tattoo used to show the illnesses or allergetic reactions one has. Medical tattoos can be used for a number of reasons:

- As a warning that a patient suffers from a chronic disease that can exacerbate suddenly and that will require immediate specialist treatment. One example is in the case of congenital adrenal hyperplasia, in which patients may need steroid replacement therapy during ordinary illness.

- As an aid in radiotherapy. In order to minimize damage to surrounding tissues, the radiotherapist seeks to keep the irradiated field as small as possible. Marking a number of points on the body with tattoos can aid radiotherapists in adjusting the beam properly.

- During breast reconstruction after mastectomy (removal of the breast for treatment of cancer), or breast reduction surgery. Tattooing is sometimes used to replace the areola which has been removed during mastectomy, or to fill in areas of pigment loss which may occur during breast reduction performed with a free nipple graft technique.

See also

- SS blood group tattoo

External links

- Medical Tattoos [1] More info about mastectomy tattoos & tattoos over scars.

Temporary tattoo

A **temporary tattoo** is an image on the skin resembling a true tattoo, but is non-permanent. Temporary tattoos can be drawn, painted, or airbrushed, as a form of body painting, but most of the time these tattoos are transferred to the skin. Temporary tattoos of any kind are used for numerous purposes including self-expression, identification, and advertising. For example, actors who wish to add to their character's distinctiveness might take temporary tattoos painted on the skin by hand or using stencils as part of their cosmetic ritual.

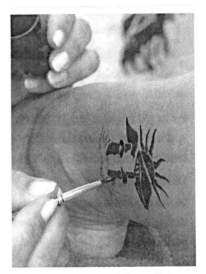

A temporary tattoo being applied.

Temporary transfer tattoos

Old fashioned temporary tattoos, which were first made popular as inserts in bubble gum, were poor quality ink transfers that often resulted in blurry designs and could easily be washed or rubbed off. A very identifiable brand would be the fruit flavored chewing gum Fruit Stripe which has been popular with American children for many years. Nonetheless, these lick-and-peel temporary tattoos became a well-known piece of Americana.

Modern temporary transfer tattoos are made of ink and glue, and last much longer than older temporary tattoos. In this process, the tattoo is applied to the outer surface of the skin and remains until such time as the image fades away (typically after 3-5 days) or is removed.

While most temporary tattoos are created commercially for advertising or as novelty items, the process of creating has been adapted to the fine art of lithography as well. And even more recently, Chanel, the Parisian fashion house, has set up a themed area in Selfridges on Oxford Street offering customers the chance to have Chanel's own transfer tattoos applied by experts. The designer offerings has been advertised (as part of Chanel's Paris Spring & Summer 2010 farmyard barn theme recreated in London) as an opportunity for fans to have the chance to have tattoo transfers applied to "areas of the private nature".

Temporary tattoos usually consist of five main elements: the front of the sheet of paper, the back of the sheet of paper, ink, glue and a protective plastic sheet. The front of the sheet is covered with a special coating upon which the tattoo image is printed with special inks. A layer of glue is then applied on top of the image. A thin, transparent plastic sheet is placed over the front of the sheet to protect the image and glue layer. The back of the sheet is left untreated and has a list of ingredients and instructions printed on it.

Transfer temporary tattoos are usually applied by removing the plastic sheet, placing the image face down against the skin and moistening the backing by wetting it thoroughly. The backing can then be carefully removed, leaving the image in place.

In 1980, temporary tattoos were created using different and exotic ink systems. 3M designed and developed a special coating called Micro-Fragrance® that made scratch-n-sniff technology possible. The temporary tattoo industry adopted the scratch-n-sniff concept and a few companies released scented tattoos.

Around this time advances in ink and screen printing were also developed. These advances made the tattoos last longer and look more realistic. As tattoos quality increased, so did demand. People began seeing temporary tattoos [1] as a product that could last and could be used outside of inexpensive giveaways.

Today, temporary tattoos are sold everywhere from vending machines to check-out counters at mass retailers to high-end boutiques. A variety of tattoo designs exist; everything from Marvel superhero tattoos, to glitter designs, to Ed Hardy temporary tattoos for trendy adults and clubbing designs for young people. Temporary tattoos have become a healthy activity for children.

Henna tattoos

Main article: Mehndi

Henna tattoos, also known as Mehndi, is another form of temporary tattoo. Coming from a south Asian tradition, henna uses a paste made from the powdered leaves of the Henna plant, Lawsonia Inermis. Its active dye, Lawsone, binds with the keratin in skin, fingernails, and hair. Traditional henna is drawn in delicate patterns on the hands and feet, but modern henna is applied in all sorts of designs anywhere on the body. Unlike other forms of temporary tattoos, henna does not allow for a full range of colors but only shades of reds, browns, and near-blacks. The paste is applied and left on the skin for

Mehndi on a hand.

several hours to stain. The stain will gradually fade away as the skin sheds. Henna tattoos can last days to over a month depending on application and aftercare.

However, caution should be taken as many products labeled henna are misleading. Fast-staining "black henna" can contain para-phenylenediamine (PPD) which can cause allergic reactions and scarring.

Temporary airbrush tattoos

Temporary airbrush tattoos are another kind of temporary tattoo. Like other forms of temporary tattoos are applied to the surface of the skin and do no damage to the skin. Airbrush tattoos are created by placing a stencil to the skin and delivering the tattoo ink or tribal airbrush tattoo paint with an airbrush. Unlike temporary transfer tattoos, the artist can control delicate elements of the temporary tattoo while it is being produced, which is much more similar to the true permanent tattoo experience.

Temporary Airbrush Tattoos have been in existence since about 1998 and are largely used in marketing, advertising and the entertainment industry. Because of the constant research and development of superior airbrush equipment and inks, airbrush tattoos [2] today so closely resemble real tattoos that many people cannot tell the difference.

Temporary airbrush tattoo removal

Most airbrush tattoo inks/paints are alcohol-based. Applying baby powder several times during the day will extend the life of the tattoo. Removal is done by applying an oil or alcohol based product. Baby oil, mineral oil and suntan lotion work best. Isopropyl alcohol (rubbing alcohol) also works, but should be used with caution as it can dry and irritate the skin. They last from a couple of days up to a week depending on how often the area is washed and taken care of.

Temporary variants of permanent tattoos

Some tattoos applied with a tattoo gun may be less permanent or easier to remove; however, as these involve insertion of pigments under the skin and do not involve the removal or degradation of all materials involved, they can not be considered completely temporary.

Removable tattoos

Specially formulated inks are much easier to remove. Last only 3-6 months. This ink is a disappearing ink. Currently InfinitInk is such an ink, available in the US. It contains all the pain of a real tattoo but fades away.

Semi-permanent tattoos

Some practitioners offer tattoos that they claim to be temporary, but will last for a period of years rather than days. These are applied using a tattoo gun, and are therefore the closest substitute for the permanent tattoo experience, including the discomfort. These tattoos are supposed to gradually fade away over time, leaving no trace. Some tattoo artists claim that the inks are inserted closer to the surface, allowing them to gradually slough off, while others claim to use special inks that naturally disperse over time.

There is some discrepancy as to whether these semi-permanent tattoos are in fact "temporary tattoos" at all. In practice, semi-permanent tattoos have had mixed results, and caution would say that any tattoo performed by inserting pigment under the skin should be considered permanent.

See also

- Body painting
- Mehndi (so-called henna tattoos)
- Tattoo
- Fusen gum

References

- Temporary Henna Tattoos [3]

External links

- Tattoo Sleeves [1]
- Inkwear temporary tattoos [1]
- Temporary Airbrush Tattoos (http://www.strawberrystudioart.co.uk)

Teardrop tattoo

The **teardrop tattoo** or **tear tattoo** is a symbolic tattoo that is placed underneath the eye. This tattoo originated with Chicano gangs in California . The meaning was that the wearer had killed someone. Since, the meaning of the tattoo has, "strayed from its gang roots and is open to meanings." Now, there are various meanings and variations of the teardrop tattoo, which can symbolize losing a loved one or spending time in prison. . It is also often used in prison to warn other convicts that the wearer has killed.

Photograph of Lil Wayne with teardrop tattoos below his eyes.

See also

- Tattoo ink
- Tattoo artist
- Criminal tattoo

Criminal tattoo

Tattoos are used among criminals to show gang membership and record the wearer's personal history—such as his or her skills, specialties, accomplishments and convictions. They are also used as a means of personal expression. Certain designs have developed recognized coded meanings. The code systems can be quite complex and because of the nature of what they encode, the tattoos are not widely recognized.

Australia

Prisoners who were transported from Britain to Australian penal colonies between 1787 and 1867 were sometimes tattooed with marks intended to signify disgrace, for example D for deserter. However, prisoners often modified these tattoos to conceal the original design or to express wry or rebellious messages.

A Mara Salvatrucha gang member with a tattoo showing his gang membership

North America

Common tattoos are names of relatives or gang members, symbols of aggression, tattoos advertising a particular skill, or religious imagery. One of the most well-known tattoos is the teardrop tattoo, which commonly indicates the bearer has killed.

Another common tattoo in American prisons and jails, especially for Hispanic inmates, is three dots on the top of the hand between the index finger and thumb, similar to what is described for French criminal tattoos below. The trio is meant to symbolize alternatively the Trinity (Catholic & Christian imagery is common in the US penal system) or 'Mi Vida Loca.' (My Crazy Life in Spanish)

Africa

Egyptian tattoos

- Ankh – Eternal life
- Anubis – Protection from death
- Eye of Horus – Protection from enemies/back-stabbers

Eye of Horus

France

In France, tattoos of five dots resembling the dots on a die, placed on the hand between index finger and thumb are found on prison inmates. This tattoo represents the individual between the four walls of the prison cell (*un homme entre quatre murs* - a man between four walls).

Tattoos of 3 dots on the hand means "death to cops" (*mort aux flics*).

Until the abolition of the death penalty in 1982, criminals sentenced to death might have a dotted line around the neck with "cut along the line" caption.

A single dot on the cheek usually means the wearer is a pimp (*point des maquereaux*).

A stick figure holding a trident is also a common French prison tattoo.

Russia and former Soviet republics

Main articles: Vor v zakone and Russian mafia

Criminal tattoos

Russian criminal tattoos have a complex system of symbols which can give quite detailed information about the wearer. Not only do the symbols carry meaning but the area of the body on which they are placed may be meaningful too. The initiation tattoo of a new gang member is usually placed on the chest and may incorporate a rose. A rose on the chest is also used within the Russian Mafia. Wearing false or unearned tattoos is punishable in the criminal underworld. Tattoos can be voluntarily removed (for loss of rank, new affiliation, "life style" change, etc.) by bandaging magnesium powder onto the surface of the skin, which dissolves the skin bearing the marks with painful caustic burns. This powder is gained by filing "light alloy" e.g. lawnmower casing, and is a jailhouse commodity.

Tattoos done in a Russian prison are normally paid through a sexual favour and have a distinct bluish color and usually appear somewhat blurred because of the lack of instruments to draw fine lines. The ink is often created from burning the heel of a shoe and mixing the soot with urine, and injected into the skin utilizing a sharpened guitar string attached to an electric shaver.

In addition to voluntary tattooing, tattoos are used to stigmatize and punish individuals within the criminal society. They may be placed on an individual who fails to pay debts in card games, or otherwise breaks the criminal code, and often have very blatant sexual images, embarrassing the wearer. Tattoos on the forehead are usually forcibly applied, and designed both to humiliate the bearer and warn others about him or her. They frequently consist of slurs about the bearer's ethnicity, sexual orientation, or perceived collusion with the prison authorities. They can indicate that the bearer is a member of a political group considered offensive by other prisoners (e.g. Vlasovite), or has been convicted of a crime (such as child rape) which is disapproved of by other criminals.

Tattoos that consist of political or anti-authoritarian statements are known as "grins". They are often tattooed on the stomach of a thief in law, as a means of acquiring status in the criminal community. A Russian criminologist, Yuri Dubyagin, has claimed that, during the Soviet era, there existed "secret orders" that an anti-government tattoo must be "destroyed surgically", and that this procedure was usually fatal.

Motifs

- Barbed wire; tattooed across the forehead signifies a sentence of life imprisonment without possibility of parole.
- Birds over horizon: meaning "I was born free and should be free"
- Cat: a career as thief, a single cat means the bearer worked alone, several cats mean the bearer was part of a gang
- Churches, fortresses, etc., are often tattooed on the chest, back, or hand. The number of spires or towers can represent the years a prisoner has been incarcerated, or number of times he has been imprisoned. The phrase, "The Church is the House of God," often inscribed beneath a cathedral, has the metaphorical meaning, "Prison is the Home of the Thief."
- Madonna and baby Jesus: Indicates the person has been a thief since childhood.
- Dagger sex offender
- Executioner: Murderer
- Spider or spider web: may symbolize doing time in prison
- Tombstones: also represents the loss of time, you may see the number of years that are served (i.e. 5 tombstones reading 2001 - 2005 means the prisoner has done 5 years)

Nazi insignia

- SS: two sig runes were the symbol of the Schutzstaffel

See also

- Gang signal
- HWDP, Polish anti-Police acronym
- Irezumi, Japanese tattooing
- Russian Mafia
- Teardrop tattoo
- Triad (underground society)
- Yakuza

References

Other sources

- *Russian Criminal Tattoo Encyclopedia Volume I* Danzig Baldaev, ISBN 3-88243-920-3
- *Russian Criminal Tattoo Encyclopedia Volume II* Danzig Baldaev, ISBN 978-0955006128
- *Russian Criminal Tattoo Encyclopedia Voume III* Danzig Baldaev, ISBN 978-0955006197
- *Russian Prison Tattoos: Codes of Authority, Domination and Struggle* Alix Lambert, ISBN 0-7643-1764-4
- *The Mark of Cain* (2000), film on Russian criminal tattoos; DVD, ASIN B0011UBDV8

Further reading

- Lina Goldberg, *Gang Tattoos: Signs of Belonging and the Transience of Signs* [1]

External links

- Russian criminal tattoo photos and meanings [2]

Body suit (tattoo)

A **body suit** or **full body suit** is an extensive tattoo, usually of a similar pattern, style or theme that covers the entire torso or the entire body.

They are associated with freak show and circus performers, as well as with traditional Japanese tattooing.

Such suits are of significant cultural meaning in some traditional cultures, representing a rite of passage, marriage or a social designation.

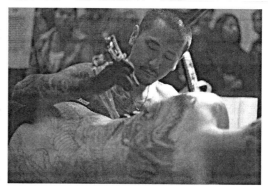

Tattoo artist working on a body suit.

Notable wearers

- Katzen
- The Enigma
- The Lizardman
- Stalking Cat
- Lucky Diamond Rich
- Julia Gnuse
- Leopard Man of Skye

See also

- Body painting
- Body modification

External links

- An example picture of a "cat suit" [1]
- History, culture and pictures. [2]
- Matt Gone full bodysuit tattoo. [3]

Christian tattooing in Bosnia and Herzegovina

Part of a series on the
Culture of Croatia
Timeline
History of Croatia
Medieval Kingdom
Renaissance
National Revival
Culture and Traditions
Alka · Cuisine · Dance · Dress · Easter egg · Kinship · Language · Tamburical · Tattoos · Wine
Arts
Art · Architecture · Cinema · Literature · Music ·
Religion
Religion · Christmas Eve · Gospa Sinjska · Marija Bistrica · Medugorje · Saint Joseph · St. Mark's Church · Old Church Slavonic
Society
Education · Nature parks · Matica hrvatska · Sports · Radio · Television · World Heritage Sites
Symbols
Flag of Croatia · Croatian Coat of Arms · Licitar · Lijepa naša domovino · wattle
Croatia Portal

Christian tattooing in Bosnia and Herzegovina was widespread among Croatian Catholic community during the Turkish occupation of Bosnia and Herzegovina (1463-1878) and up until the 20th century. Croats would tattoo their children in order to save them from Turks who kidnapped them during Ottoman occupation of Bosnia and Herzegovina, while Croatian women were tattooed in hopes of protecting themselves from being taken away by Turkish men into captivity. Tattooing became widespread after the Ottomans would take children into captivity and send them to Turkey where they

were trained to be soldiers or servants.

Even today Croatian women in some parts of Bosnia tattoo their hands with Christian symbols and stechak ornaments. This very old custom, used exclusively among Catholic Christians, had a special meaning in the period of the Ottoman occupation. This type of custom has been common throughout history: one example is the Greek historian Strabo (1st century BC) who mentions tattooing among inhabitants of this area, along with another that it is an old Illyrian custom.

Bosnian Catholic Croats tattoo their hands and other visible parts of body with Christian symbols (usually with a small cross), like brow, cheeks, wrist, or below neck. This can be seen even today, not only in Bosnia and Herzegovina, but among Bosnian Croat women living in abroad.

See also

- Croats of Bosnia and Herzegovina
- tattoos

External links

- Croats in Bosnia and Herzegovina [1]
- I Never Knew My Baba Had a Tattoo [2]

Tattoo Artists in the Media

Lucky Diamond Rich

Lucky Diamond Rich	
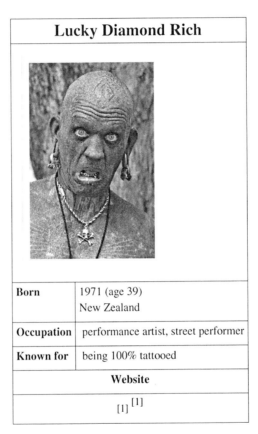	
Born	1971 (age 39) New Zealand
Occupation	performance artist, street performer
Known for	being 100% tattooed
Website	
[1] [1]	

Lucky Diamond Rich (born 1971, New Zealand) is "the world's most tattooed person" (a title formerly held by Tom Leppard), and has tattoos covering his entire body, including the inside of his foreskin, mouth and ears. He holds the Guinness world record as of 2006, being 100 percent tattooed.

He is also a performance artist and street performer whose act includes sword-swallowing, unicycling and juggling.

Lucky Diamond Rich

Inspiration and first tattoo

As a young boy, he read about and began to have recurring thoughts of the most tattooed men and women. It did not go much further than just a thought until he got his first tattoo, it was of a small juggling club on his hip.

See also

• Body suit (tattoo)

External links

• Lucky Diamond Rich homepage [1]
• An interview from 2004 [2]
• Video interview from Tattoo Convention Amsterdam 2007 [3] - YouTube
• Interview from The Sydney Morning Herald [4]

LA Ink

LA Ink	
Logo of the show	
Format	Reality television
Starring	Kat Von D Corey Miller Hannah Aitchison (Season 1-2) Kim Saigh (Season 1-2) Pixie Acia (Season 1) Dan Smith (Season 3-)
Country of origin	United States
No. of seasons	4
No. of episodes	74 (Episode List)
Production	
Location(s)	Los Angeles, California, West Hollywood, Upland
Running time	45-48 minutes
Broadcast	
Original channel	TLC
Picture format	PDTV
Original run	August 7, 2007 – Present
Chronology	
Related shows	*Miami Ink* *London Ink*
External links	
Official website [1]	

LA Ink is an American reality show on TLC that follows the events of the High Voltage Tattoo (and, later in the series, American Electric) tattoo studios in Los Angeles, California. The spin-off of TLC's *Miami Ink*, it premiered on August 7, 2007.

Background

See also: List of LA Ink episodes

High Voltage Tattoo in West
Hollywood, CA.

After leaving the hit program *Miami Ink* due to a dispute with her fellow cast members, Kat Von D moved back to Los Angeles to open her own tattoo shop and was offered her spin off. Initially, she hired her close friend Pixie Acia to be the shop manager, and also her good friend Corey Miller as the tattoo artist. After considering many more artists for the job, Kat hired Hannah Aitchison and Kim Saigh to work for her, as well. The cameras follow her as she opens the shop, while capturing everything that unfolds in between.

Each customer coming into the shop usually has a story or reason behind their tattoo. On occasion, even known celebrities make an appearance to get tattooed by Kat or one of the other artists.

Inevitably, as the show progressed, changes occurred. Kat fired Pixie during the second half of season 1 and then Kim and Hannah left the show after the season 2 finale. The first half of Season 3 premiered with a new shop manager, former *Rock of Love* competitor Aubry Fisher but was fired by Kat during the season premiere of the second half of season 3 after getting into a lot trouble with most of the people at the shop.

Tattoo artist Amy Nicoletti was hired on a trial basis, but left to work at American Electric, owned by Craig Jackman. Tattoo artist Paulie Tattoo was also hired and quit to go to American Electric, due to lack of work. Aubry soon joined the two of them as a "shop helper" at American Electric after she got fired from High Voltage when Amy and Paulie try to convince her in getting a job at the shop before leaving abruptly to pursue her dreams of becoming a make-up artist. She was later fired from American Electric as well, but does make a couple of appearances in the fourth season.

Kat broke a Guinness world record on the show, tattooing 400 people the "LA" part of the *LA Ink* logo in 24 hours, giving the money raised to charity. The record was broken in June, 2008 by Kat's ex-husband Oliver Peck who tattooed 415 tattoos of the number "13".

During the first half of season 3, Nikko Hurtado can be seen as a guest artist on the show several times while Kat's sister Karoline and her brother Michael also make appearances on the show.

After Aubry was fired from High Voltage, Kat hired Liz Friedman after going through several of the girls' resumes who were trying out to become the new shop manager. Liz was fired in the season finale of the second half of season 3 after being caught by Dan and Adrienne lying to Corey about Kat by saying something that was not true and giving him time off without checking in with Kat.

Ratings

LA Ink premiered on August 7, 2007, averaging 2.9 million total viewers at its timeslot. According to *The Hollywood Reporter*, the number makes the show the most-watched series debut for the cable channel since the premiere of the US version of *What Not to Wear* in January 2003. This is also the highest-rated series premiere in the history of TLC among adults 18-34, with a rating of 2.6 and a viewer count of 1.5 million. The premiere was also the highest-rated basic cable primetime program last Tuesday among several major adult demographics, including 18-34, 18-49 and 25-54.

Main cast

Shop Owner

- Kat Von D

Shop Managers

- Pixie Acia (season 1)
- Aubry Fisher (season 3)
- Liz Friedman (season 3)

Tattoo Artists

- Corey Miller
- Hannah Aitchison (season 1-2)
- Kim Saigh (season 1-2)
- Dan Smith (season 3-)
- Amy Nicoletto (season 3-)
- Paulie Tattoo (season 3-)
- Ruth Pineda (Ruthless) (season 4-)

Celebrity Clientèle

The following celebrities have appeared on *LA Ink*:

- Eric Balfour, actor (*Six Feet Under* and *24*) and lead vocalist of Born as Ghosts
- Steve-O, celebrity prankster (*Jackass*)
- Ralph Saenz, lead vocalist of Steel Panther
- Eve, rapper
- Jesse Metcalfe, actor (*Desperate Housewives*)
- Mike V, skateboarder and lead vocalist of Mike V and the Rats
- Emerson Drive, Canadian country band
- Audrey Truelove, High Voltage Tattoo
- Scott Ian, guitarist of Anthrax
- Frank Iero, guitarist of My Chemical Romance
- Jesse Hughes, lead vocalist and guitarist of Eagles of Death Metal
- Jenna Jameson, pornstar
- Jeffree Star, MySpace celebrity and singer
- Matt Skiba, lead vocalist and guitarist of Alkaline Trio
- Sebastian Bach, former lead vocalist of Skid Row and actor
- Toryn Green, former lead vocalist of Fuel
- Margaret Cho, actress and comedian

- Rita Haney, widow of Pantera guitarist Dimebag Darrell
- Derek Hess, artist
- Candice Michelle, actress and former WWE Diva
- Mike Escamilla, professional BMX rider
- Jared Leto, actor, lead vocalist and guitarist of 30 Seconds To Mars
- Bam Margera, professional skateboarder, actor, and prankster (*Jackass*, and *Viva La Bam*)
- Ville Valo, lead vocalist of HIM
- Tom Green, actor and comedian
- Joanna Angel, pornstar
- Ja Rule, rapper
- The Game, rapper
- Brennan Tiffany, lead vocalist of Space Station Wagon
- Amanda Beard, 7 time Olympic gold medal winner in swimming
- Blake Lewis, *American Idol* season 6 runner-up
- Nikki Sixx, bassist of Mötley Crüe
- Lucas Silveira, lead vocalist and guitarist of The Cliks
- Tim Lambesis, lead vocalist of As I Lay Dying
- Brian "Head" Welch, former guitarist of Korn and musician
- Jeph Howard, bassist of The Used
- Tim Lopez, guitarist of Plain White T's
- Jonas Jizay, Trash Comedian and Porn King
- Patty Schemel, former drummer of Hole
- Dave Navarro, guitarist of Jane's Addiction
- Yolanda Perez, singer
- Matt Bradely, reality star (*Deadliest Catch*)
- Luke Johnson, drummer of Lostprophets
- Ronnie Radke, former lead vocalist of Escape the Fate and vocalist of Falling in Reverse
- Wes Borland, guitarist of Limp Bizkit and guitarist and vocalist of Black Light Burns
- Pastor Fred Zariczny (Pastor Z) founder of Bikers for Christ
- Lamar Odom, professional basketball player of the Los Angeles Lakers
- Nick Wheeler, guitarist of The All-American Rejects
- Lemmy, vocalist and bassist of Motörhead
- Natasha Kai, professional soccer player and Olympic Gold medal winner
- Kristoff St. John, actor (*The Young and the Restless*)
- Allen Alvarado (his father got a tattoo of Allen), actor
- Matt Sorum, drummer of Guns N' Roses and Velvet Revolver
- Crispin Earl, vocalist of The Veer Union
- Phil Plait, astronomer and author

- Jason Mraz, singer/songwriter
- Otep Shamaya, singer of Otep, poet, and actress
- Lady Gaga, singer/songwriter
- Aaron Lewis, lead singer of Staind
- Soulja Boy Tell 'Em, rapper and record producer
- Dr. Chud, former drummer of The Misfits
- Shontelle, singer/songwriter
- Chantal Claret, vocalist for Morningwood
- Eddie Bravo, Brazilian Jiu-Jitsu Practitioner and Musician
- Dominic Monaghan, actor (*Lost* and *The Lord of the Rings*),
- Kimberly Caldwell, *American Idol* Season 2 finalist
- Bobcat Goldthwait, actor and comedian
- Travis McCoy, singer/songwriter and rapper of Gym Class Heroes
- Felix Rodriguez, guitarist of The Sounds
- Shelly Fairchild, singer/songwriter
- Nick Barnett, linebacker for Green Bay Packers
- Jimmy Urine, vocalist of Mindless Self Indulgence
- Phil Collen, guitarist of Def Leppard
- Robin Wilson, lead vocalist of Gin Blossoms
- Trever Keith, lead vocalist and guitarist of Face To Face

External links

- Official website [1]
- *LA Ink* [2] at the Internet Movie Database
- High Voltage Tattoo website [3]
- Kat Von D website [4]
- Making LA Ink [5], *DV Magazine*
- Members of the cast [6], *Inked Magazine*
- Q&A with Pixie Acia of *LA Ink* [7]
- Kim Saigh [8], *Inked Magazine*

Kat Von D

Kat Von D	
Born	Katherine Drachenberg March 8, 1982 Monterrey, Nuevo Leon, Mexico
Other names	Katherine Drachenberg
Occupation	Tattoo artist, Television personality
Spouse	previously married to Oliver Peck
Website	
http://www.katvond.net/	

Kat Von D (born **Katherine Drachenberg**, March 8, 1982), is an American tattoo artist and television personality. She is best known for her work as a featured tattoo artist on the TLC reality television show *Miami Ink*. A subsequent TLC series *LA Ink*, premiered August 7, 2007 in the United States and November 11, 2007 in the UK.

Biography

Kat Von D was born in Nuevo Leon, Mexico. Her parents were both born in Argentina. Her father, René Drachenberg, is of German descent and her mother, Sylvia Galeano, is of Italian-Chilean descent. A middle child, Von D has a sister named Karoline and a brother named Michael. She moved with her family to the Los Angeles area at age 4 and grew up in Colton, California. She credits the prominent Latino culture of Los Angeles as being a major influence drawing tattoos in her art and style. She began listening to the Ramones, the Misfits and other punk rock bands at the age of 12. She got her first tattoo at 14 and quit school at 16 to become a tattoo artist.

Von D was asked to work at Miami Ink when Darren Brass hurt his elbow preventing him from tattooing. She appeared in the first three seasons of the same-name reality TV show taped there. She had a falling out with Ami James which led to her leaving the shop and the show, and has said she

hasn't spoken with members of Miami Ink since her departure.

Following this she got her own series, *LA Ink*, following her work at her tattoo shop, High Voltage Tattoo, in Hollywood, California. On the show, she gained the Guinness World Record of most tattoos given by a single person in 24 hours, with a total of 400. This was broken shortly after by her ex-husband Oliver Peck with 415, then Derek Kastning with 726, and after that by Hollis Cantrell with 801.

She has a book compiling her artworks and tattoos, released in January 2009, called *High Voltage Tattoo*, with a foreword by Mötley Crüe's Nikki Sixx. The book traces Von D's career as an artist, from early childhood influences to recent work, along with examples of what inspires her, information about the show and her shop, her sketches, and personal tattoos. Von D described the book as "not an autobiography, you know, 'cause I'm too young to do that. But this is just kind of like a picture-driven outline of my career as an artist. So, you see everything from my drawings when I was six to tattoos that have never before been seen." She was one of the contributors to Carrie Borzillo-Vrenna's book *Cherry Bomb* in which she gave tips on tattooing.[citation needed]

Von D created a make-up line for Sephora, and is the creator of the Musink festival.

Von D was married to fellow tattoo artist Oliver Peck, but were done by 2007. She dated Nikki Sixx from 2008 to Jan 2010. She is currently dating Jesse James.

In September 2010, she opened Kat Von D's Wonderland Gallery [1].

Celebrity fans

Von D was referred to in the Eagles of Death Metal song "High Voltage", which was named after her shop and is featured on their third album, *Heart On*. In an interview, Eagles of Death Metal's Jesse Hughes said, "I wrote that for Kat Von D, because that girl's bad ass."

Musical tastes

Von D was classically trained in piano beginning at age 6. She particularly appreciates Ludwig van Beethoven. Von D has tattooed herself with the emblems of the bands Misfits, HIM, Turbonegro, ZZ Top, Guns N' Roses, AC/DC, Slayer, Mike Got Spiked and "Slutallica", a modified Metallica logo. She appeared in the music video of Alkaline Trio's "Help Me", as well as HIM's Killing Loneliness. Other musical artists that Von D lists among her favorites include The Mars Volta and Selena. She also likes the band 30 Seconds To Mars and is featured on the cover of "This Is War" as one of the 2,000 fans chosen.[citation needed]

Filmography

As well as cameos and various chat show appearances, TV, film, and video game appearances include:

- *Miami Ink*, 2005–2006
- *LA Ink*, 2007–present
- *MADtv*, April 5, 2008
- *The Bleeding* as Vanya
- *Tony Hawk: Ride* (video game) unlockable skater, November 17, 2009

External links

- Official website [4]
- Kat Von D [2] at the Internet Movie Database
- Kat Von D [3] at TV.com
- Kat Von D interview [4], *Inked*
- Kaufman, Amy (2008-01-06). "Marked sensation" [5]. *LA Times*. Retrieved 2008-06-03.
- Kat Von D podcast interview [6] at Juliland.com

Miami Ink

Miami Ink	
Format	Reality
Starring	Ami James Chris Núñez Chris Garver Darren Brass Yoji Harada Saru Sammyr Tim Hendricks (season 4) Kat Von D (season 1-3)
Country of origin	United States
No. of seasons	6
No. of episodes	114
Production	
Executive producer(s)	Charlie Corwin Clara Markowitz Jamie Shutz
Running time	45–48 minutes
Broadcast	
Original channel	TLC
Picture format	PDTV, 720p, HDTV, 1080i, HDTV
Original run	July 19, 2005 – August 21, 2008
Status	Ended
Chronology	
Related shows	*LA Ink* *London Ink*
External links	
Official website [1]	

Miami Ink is an American reality show on TLC that follows the events that took place at a tattoo shop in Miami Beach, Florida. The show premiered in July 2005 and has finished broadcasting its fourth season. The show led to several spin-offs, including the shows *LA Ink* and *London Ink* which are also broadcast on TLC.

History

The shop, which was called *305 Ink* (with 305 being a reference to the Miami area code) before the show started, is now called Love Hate Tattoo and is co-owned by tattoo artists Ami James and Chris Núñez, and also features artists Chris Garver, Darren Brass, Tim Hendricks and Yoji Harada. Kat Von D first joined the shop during the first season while Brass had an injured arm. She then returned as a full time crew member for two seasons, after which she returned to Los Angeles and landed her own *Miami Ink* spin-off entitled *LA Ink* which premiered in August 2007. Another spinoff, *London Ink* began on Discovery Real Time in the UK in September 2007. On October 28, 2008, a third spin-off, called *Rio Ink*, featuring a Rio de Janeiro tattooshop, aired on the Discovery Channel People & Arts channel in Brazil.

Each episode featured a number of customers along with their backstories and motivations for choosing their tattoos. In addition, there was some focus on the personal lives of the artists. Most of the episodes are narrated by James, with Nuñez occasionally filling in. The main musical theme for the show is "Funky Kingston" by Toots & the Maytals. The show has on occasion featured the personalities from other TLC shows such as *American Chopper*.

Cast of Miami Ink

The original Miami Ink shop has now become a full retail shop for the clothing line DeVille, but James and Núñez have opened a bigger tattoo shop, called LoveHate Tattoo, next door.

International screenings

Miami Ink has been shown mainly on channels of the Discovery Network, including Discovery Real Time (UK, Ireland, France, Italy), the Discovery Channel (Norway, Poland, Denmark, Romania, Finland, The Netherlands, South Africa, Namibia, Belgium, Turkey, Portugal, Czech, Spain), DMAX (UK, Ireland and Germany), Discovery Travel and Living (Croatia, India, Italy, Russia, Serbia, Asia, Australia, New Zealand, Poland, Romania, Bulgaria, Hungary, Macedonia, Denmark, Singapore) and People & Arts (Latin America, Spain, Portugal and Brazil). It has also been broadcast by Viasat 4 (Norway), TV6 (Sweden), TV3+ (Denmark) and JIM (Finland).

Celebrity customers

The following celebrities have appeared on *Miami Ink*:

- Evan Seinfeld, vocalist for Biohazard and adult film star
- Sunny Garcia, pro surfer
- Bam Margera, professional skateboarder and actor
- Mark Zupan, athlete
- H2O, band
- Phil Varone, drummer of Skid Row and Saigon Kick
- Anthony Bourdain, celebrity chef
- Harold Hunter, skateboarder
- Lloyd Banks, rapper
- Johnny Messner, actor
- Jesse Hughes, musician of Eagles of Death Metal
- Ivy Supersonic, fashion designer
- Chris Jacobs, host of TLC's *Overhaulin'*
- Reginald 'Fieldy' Arvizu, bassist for Korn
- Craig Ferguson, actor and comedian
- Randy Orton, WWE Superstar
- Abraham Quintanilla III, Mexican-American musician and producer
- Paul Teutul, Sr., mechanic from *American Chopper*
- Paula Meronek, TV personality from *The Real World*
- MickDeth, bassist for Eighteen Visions
- DJ Skribble, DJ
- Mr. J. Medeiros, rapper
- Gianna Lynn, adult film star
- Frank Iero, guitarist for My Chemical Romance
- Jeffree Star, Internet personality
- Ronnie Radke, vocalist for Escape The Fate

See also

- *Ink Wars*
- *Inked*
- *LA Ink*
- *London Ink*

External links

- Official website [1]
- *Miami Ink* [2] at the Internet Movie Database
- Exclusive Interview With Yoji Harada [3]

Ami James

Ami James	
Born	Ami James April 6, 1972 Israel
Nationality	Israeli
Occupation	Tattoo artist Entrepreneur Clothing Former television personality
Known for	Co-owner of Love Hate Tattoos (Miami Ink). Co-owner of Love Hate Choppers and DeVille clothing.
Home town	Miami, Florida, USA
Website	
http://www.amijamestattoo.com http://www.devilleusa.com/ [1]	

Ami James Birth name Omi James (April 6, 1972), is an Israeli-born American tattoo artist. His father, an American, converted to Judaism three years prior to moving to Israel, where he joined the Israeli army and met Ami's mother. Ami lived in both Israel and Egypt as a child, and spent much of his childhood without his father who left the family when Ami was five years old. Suffering from severe ADD, Ami explains that he was drawn into art and tattooing from a young age as his father had tattoos and was also a painter.

He moved to the United States aged 11 or 12, moving in with his father's parents before moving to Miami at the age of 12. He moved back to Israel in his teens and completed his military service in the Israel Defense Force as a sniper. At the age of 15 he got his first tattoo, a strong experience which made him determined to become a tattoo artist himself. In 1992, he started his apprenticeship with a tattoo artist; Lou at the store *Tattoos By Lou*. He is the co-owner (with Chris Núñez) of the Miami Beach, Florida tattoo parlor Love Hate Tattoos, the subject of the TLC reality television program, Miami Ink. James also co-owns the DeVille clothing company with Núñez and Jesse Fleet, and the Miami nightclub Love Hate Lounge, with Núñez and two other close friends. He has also created designs for Motorola's RAZR V3 mobile phones. His ex-wife, Jordan, gave birth to their only child, Shayli Haylen James on August 3, 2008. Ami has also just recently invested in a jewelry line, Love Hate Choppers Jewelry, with Boston jeweler Larry Weymouth.

In 1996 he lived for a few months in Denmark, where he did tattoos in Nyhavn.

External links

- Online Store [2]
- Official Blog [3]
- Ami James [4] on Love Hate Tattoos
- Ami James [5] on TLC
- Ami James [6] on IMDB

London Ink

London Ink	
Format	Reality television
Starring	Louis Molloy Dan Gold Nikole Lowe Phil Kyle
Country of origin	🇬🇧 United Kingdom
No. of series	3
No. of episodes	12
Broadcast	
Original channel	Discovery Real Time
Original run	September 23, 2007 − Present
Chronology	
Related shows	*Miami Ink* *LA Ink* *Rio Ink*
External links	
Official website [1]	

London Ink is a reality show on Discovery Real Time that follows Louis Molloy and three other tattoo artists.

Each of the artists brings a different style to London Ink. Louis Molloy, is an expert in parallel and straight lines and other difficult shapes, and has tattooed David Beckham. Dan Gold is an avid graffiti artist in the freehand new wave graffiti style. New Zealand artist Nikole Lowe specializes in Japanese, Tibetan and Indian-themed art. American Phil Kyle brings a new wave old school style with his own twist over to England. The show is a spin-off of *Miami Ink* and premiered on September 23, 2007.

The first episode was filmed at London Tattoo at 332 Goswell Rd, Islington, London.

Glamour model Emily Scott appeared in the first episode of *London Ink*, in which she had a Koi fish tattooed on her right arm by Dan Gold.

See also

- *Miami Ink*
- *LA Ink*
- *Inked*
- *London Tattoo*

Alex Kramer has also been a customer.

External links

- London Ink at Discovery Real Time [2]
- London Ink Blog [3]
- London Ink's official Myspace [4]
- London Ink's unofficial Bebo Page [5]

Inked

Inked	
Genre	Reality television
Written by	Gregg Backer Jeff Bowler
Country of origin	United States
Language(s)	English
No. of seasons	2
No. of episodes	40
Production	
Location(s)	Las Vegas, Nevada
Running time	30 minutes
Production company(s)	Boom Pictures
Broadcast	
Original channel	A&E Network
Original run	July 20, 2005 – October 17, 2006
Status	Ended

Inked is a documentary television series about the employees of the Hart & Huntington Tattoo Company in the Las Vegas metropolitan area. The series was created by Jeff Bowler in 2005, and was broadcast by the A&E Network. The theme song was written and performed by Height of Roman Fashion.

Episodes

Season One

1. "Change of Hart" - Original airdate: July 20, 2005
2. "Pull It Together, Dizzle" - Original airdate: July 20, 2005
3. "The Trouble With Quinn" - Original airdate: July 27, 2005
4. "Love on the Rocks" - Original airdate: August 3, 2005
5. "Meet the New Boss" - Original airdate: August 10, 2005
6. "The Big Event" - Original airdate: August 17, 2005
7. "Busting Out" - Original airdate: August 24, 2005
8. "Florida Dreamin'" - Original airdate: August 31, 2005

9. "A Very Vegas Wedding" - Original airdate: September 7, 2005

10. "Get a Leg Up, Thomas" - Original airdate: September 14, 2005

11. "The Trouble With Nina" - Original airdate: September 21, 2005

12. "Old School vs. Nu Skool" - Original airdate: September 28, 2005

13. "Dizzle Redux" - Original airdate: October 27, 2005

14. "Supersize My Hart"

15. "Trouble in Paradise"

16. "Steve O & Skin Poetry"

17. "Skindred Spirits & the Salute"

18. "The Proposal and the Impersonator"

19. "Rockers & Ribbons"

20. "Cover-Ups and Pin-Ups"

21. "Traditional & Tributes"

22. "Dominoes & DNA"

23. "Pain & Pride"

24. "Health & Humility"

Season Two

1. "Not Your Average Joey"

2. "Dizzle Out to Pastor"

3. "Basket Case"

4. "Jenn-uine Trouble"

5. "Murphy's Law"

6. "Go West, Young Diz"

7. "Carey's Little Helper"

8. "Habitattoo for Humanity"

9. "Jumping the Gun"

10. "The Hot Seat"

11. "Tat and Rap"

12. "Dress for Success"

13. "Mud, Sweat & Tears"

14. "Surf & Murph"

15. "Always in Fashion"

16. "Crossing the Line"

External links

- *Inked* TV Show Official website [1]

Inked (magazine)

Editor	Rocky Rakovic
Categories	Tattoo magazine
First issue	2004
Company	Quadra Media
Country	United States
Language	English

Inked is a high-end glossy tattoo lifestyle magazine that debuted in late 2004 and was published quarterly for one year. In 2006, the magazine was purchased by Downtown Media Group but never published an issue. Donald Hellinger, president of Nylon Holding, Inc. publisher of *Nylon* magazine, acquired Inked in August 2007. He hired creative director Todd Weinberger to redesign the magazine, then brought on editor Jason Buhrmester, and finally contracted software engineer Eric G. Elinow to rebuild the magazine's web software.

The magazine relaunched in October 2007 and is now published 10 times a year. The magazine targets young adults between 18 and 39 who are interested in tattoo culture, art, music, and fashion.

External links

- Official site [1]
- Inked [2] on Myspace
- Interview with Inked Creative Director Todd Weinberger at NoD: Notes on Design [3]

Lyle Tuttle

Lyle Tuttle	
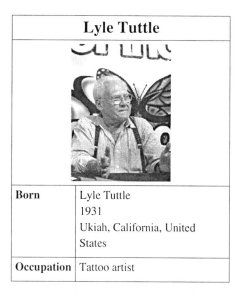	
Born	Lyle Tuttle 1931 Ukiah, California, United States
Occupation	Tattoo artist

Lyle Tuttle (born 1931) is a well-known American tattoo artist and historian of the medium, who has been tattooing since 1949.

Biographical and career information

Tuttle was born in 1931 and grew up in Ukiah, California. At the age of fourteen he purchased his first tattoo for $3.50. In 1949, he began tattooing professionally. In 1954 he opened his own studio in San Francisco. This first shop was open for nearly 30 years. Tuttle tattooed Janis Joplin, Cher, Henry Fonda and several other notable musicians and celebrities of the time.

He has been tattooed on six continents, and has never knowingly tattooed a minor. He has become a legend and a teacher within the industry in the years he has been tattooing. He officially retired in 1990 but will still occasionally tattoo his signature on a friend or acquaintance. His fame within tattooing was somewhat controversial, as many tattooists of his day disliked his statements to the press and "shameless self-promotion". When Tuttle was on the cover of Rolling Stone magazine in October 1970, Sailor Jerry put the picture inside his toilet.

Tuttle currently teaches accredited seminars in "Tattoo machine maintenance and machine building" at tattoo conventions around the United States.

When asked what made tattooing gain in popularity during his early career, he responded:

> "Women's liberation! One hundred percent women's liberation! That put tattooing back on the map. With women getting a new found freedom, they could get tattooed if they so desired. It increased and opened the market by 50% of the population - hell of the human

race! For three years, I tattooed almost nothing but women. Most women got tattooed for the entertainment value ... circus side show attractions and so forth. Self-made freaks, that sort of stuff. The women made tattooing a softer and kinder art form."

External links

- lyletuttle.com [1]
- TattooFinder.com's Tattoos-101 September 2007 interview with Lyle Tuttle [2]
- Lyle Tuttle's H2Ocean Pro Team profile [3]

List of tattoo artists

This is a **list of tattoo artists**, those tattoo artists who have helped the art of decorative tattooing gain popularity, are known for tattooing celebrities or are well known in popular culture.

Dan Henk

Kim Saigh

chiffmacher

Paul Timman

e Tuttle

Kat Von D

Name	Lifetime	Nationality	Notes
Guy Aitchison	b. 1968	American	Tattoo artist and painter based in Michigan, featured on TLC's *Tattoo Wars*. Brother of Hannah Aitchison.
Hannah Aitchison	?	American	Chicago, Illinois based artist featured on TLC's *LA Ink*. Sister of Guy Aitchison.
Phil Andros	1909–1993	American	aka Samuel Morris Steward. Artist and writer from Ohio, later based in California.
Alex Binnie	b. 1959	British	
Mark Bodé	b. 1963	American	Comic book creator formerly based in Massachusetts, now based in California.

Paul Booth	?	American	Tattoo artist for bands including Slipknot, Mudvayne, Slayer, Pantera, Soulfly and Sepultura.
Darren Brass	?	American	Miami based tattoo artist featured on TLC's *Miami Ink*.
George Burchett	1872–1953	British	Known as "King of Tattooists". Tattooed royalty and The Great Omi.
Mister Cartoon	?	Mexican American	aka Mark Machado
Vincent Castiglia	b. 1982	American	
Gabriel Cece	?	?	
Patrick Conlon	?	American	
Jason Cruz	b. 1974	American	Lead singer of punk rock band Strung Out, worked briefly as a tattoo artist.
Derek Dufresne	?	Canadian	
Fred Durst	b. 1970	American	Lead singer of rock band Limp Bizkit, worked briefly as a tattoo artist.
Chris Garver	b. 1970	American	Formerly based in New York City, now based in Florida. Featured on TLC's *Miami Ink*.
Yoji Harada	b. 1973	Japanese	Florida based tatto artist, featured on TLC's *Miami Ink*.
Don Ed Hardy	b. 1945	American	Trained under Sailor Jerry and Japanese masters, Hardy is a noted proponent of the use of Japanese tattoo designs and techniques in American work. He founded *Tattootime*.
Henry Hate	b. 1968	American	aka Henry Martinez Jr.
Dan Henk	b. 1972	American	
Herbert Hofmann	1919–2010	German	
Horiyoshi III	b. 1946	Japanese	
Nikko Hurtado	b. 1981	American	Has been a guest artist on LA Ink several times.
Greg Irons	1947–1984	American	
Ami James	b. 1972	American	Co-star of Miami Ink.
Jason Jones	?	American	
Katzen	?	American	
Greg Kulz	?	American	
Dr Lakra	b. 1972	Mexican	aka Jeronimo Lopez Ramirez
Vyvyn Lazonga	?	American	aka Beverly Bean. Well known tattoo artist from the 1970s onwards, based in Seattle.

Nikole Lowe	?	New Zealand	Based in London.
Leslie Mah	?	American	
Mark Mahoney	?	American	
Corey Miller	?	American	
Louis Molloy	?	British	
Chris Núñez	b. 1973	American	Featured on TLC's *Miami Ink*.
Samuel O'Reilly	d. 1908	American	
Opie Ortiz	b. 1971	American	
Eric Pele	b. 1969	American	
Thomas Pendelton	b. 1971	American	
Ruth Pineda	b. 1985	American	Featured on TLC series *LA Ink*.
Jacki Randall	b. 1959	American	aka J.E.Randall known for original, freehand, cartooning and artworks as popularized in the 90s.
Cliff Raven	1932–2001	American	
Jack Rudy	?	American	Known for his "black and gray" work.
Kim Saigh	b. 1973	American	One of the artists on the first season of LA Ink.
Sailor Jerry	1911–1973	American	aka Norman Keith Collins.
Henk Schiffmacher	b. 1952	Dutch	aka Hanky Panky.
Jonathan Shaw	b. 1953	American	
Janet 'Rusty' Skuse	1943–2007	British	
Dan Smith	b. 1980	British	LA Ink star
Phillip Spearman	?	Korean-American	
Madison Stone	b. 1965	American	
Sua Sulu'ape Paulo II	?	Samoan	
Paul Timman	b. 1972	American	Notable for his work on celebrities including Angelina Jolie and Drew Barrymore and his award winning line of porcelain dinnerware with Ink Dish.
Trym Torson	?	Norwegian	
Bob Tyrrell	?	American	Known for his "black and gray" portraits

Lyle Tuttle	b. 1931	American	California based artist who tattooed Cher, Jane Fonda and Janis Joplin.
Kat Von D	b. 1982	American	Featured on TLC series *Miami Ink* and *LA Ink*.
Leo Zulueta	?	American	Known as the "father of tribal tattooing".

Tattoo Medical Issues

Tattoo medical issues

A variety of **medical issues**, though uncommon, can result from tattooing. Because it requires breaking the skin barrier, tattooing may carry health risks, including infection and allergic reactions. Modern tattooists reduce such risks by following universal precautions, working with single-use items, and sterilizing their equipment after each use. Many jurisdictions require that tattooists have bloodborne pathogen training, such as is provided through the Red Cross and OSHA.

Dermatologist have observed rare but severe medical complications from tattoo pigments in the body, and have noted that people acquiring tattoos rarely assess health risks *prior* to receiving their tattoos. Some medical practitioners have recommended greater regulation of pigments used in tattoo ink. The wide range of pigments currently used in tattoo inks may create unforeseen health problems.

Infection

Since tattoo instruments come in contact with blood and bodily fluids, diseases may be transmitted if the instruments are used on more than one person without being sterilised. However, infection from tattooing in clean and modern tattoo studios employing single-use needles is rare. In amateur tattoos, such as those applied in prisons, however, there is an elevated risk of infection. To address this problem, a programme was introduced in Canada as of the summer of 2005 that provides legal tattooing in prisons, both to reduce health risks and to provide inmates with a marketable skill. Inmates were to be trained to staff and operate the tattoo parlours once six of them opened successfully.

In the United States, the Red Cross prohibits a person who has received a tattoo from donating blood for 12 months (FDA 2000), unless the procedure was done in a state-regulated and licensed studio, using sterile technique. Not all states have a licensing program, meaning that people who receive tattoos in those states are subject to the 12-month deferral regardless of the hygienic standards of the studio. Similarly, the UK does not provide certification for tattooists, and blood donations are prohibited without exception for six months following a tattoo.

Infections that can theoretically be transmitted by the use of unsterilized tattoo equipment or contaminated ink include surface infections of the skin, hepatitis B, hepatitis C, tuberculosis, and HIV. However, no person in the United States is reported to have contracted HIV via a commercially-applied tattooing process. Washington state's OSHA studies have suggested that since the needles used in tattooing are not hollow, in the case of a needle stick injury the amount of fluids transmitted may be small enough that HIV would be difficult to transmit. Tetanus risk is reduced by having an up-to-date

tetanus booster prior to being tattooed. According to the Centers for Disease Control and Prevention no data indicates an association between tattooing in the United States and increased risk for HCV infection.

In 2006, the CDC reported 3 clusters with 44 cases of methicillin-resistant staph infection traced to unlicensed tattooists

Reactions to inks

Perhaps due to the mechanism whereby the skin's immune system encapsulates pigment particles in fibrous tissue, tattoo inks have been described as "remarkably nonreactive histologically". However, some allergic reactions have been medically documented. No estimate of the overall incidence of allergic reactions to tattoo pigments exists. Allergies to latex are apparently more common than to inks; many artists will use non-latex gloves when requested.

Allergic reactions to tattoo pigments, while uncommon, are most often seen with red, yellow, and occasionally white. Reactions can be triggered by exposure to sunlight. People who are sensitive or allergic to certain metals may react to pigments in the skin with swelling and/or itching, and/or oozing of clear fluid called serum. Such reactions are quite rare, however, and some artists will recommend performing a test patch. Because the mercury and Azo-chemicals in red dyes are more commonly allergenic than other pigments, allergic reactions are most often seen in red tattoos. Less frequent allergic reactions to black, purple, and green pigments have also been noted.

Traditional metallic salts are prevalent in tattoo inks. A 3x5 inch tattoo may contain from 1 to 23 micrograms of lead; lead exposure has been linked to birth defects, cancer, and other reproductive harm. Organic pigments (i.e., non-heavy metal pigments) may also pose health concerns. A European Commission noted that close to 40% of organic tattoo colorants used in Europe had not been approved for cosmetic use, and that under 20% of colorants contained a carcinogenic aromatic amine.

MRI complications

A few cases of burns on tattoos caused by MRI scans have been documented. Problems tend to occur with designs containing large areas of black ink, since black commonly contains iron oxide; the MRI scanner causes the iron to heat up either by inducing an electrical current or hysteresis . Burning can occur on smaller tattoos such as "permanent makeup" , but this is rare. Non-ferrous pigments have also been known to cause burns during an MRI [citation needed]. It should be stressed that tattoo burns are rare, so merely having a tattoo should not be a cause to not get an MRI scan if necessary.

Dermal conditions

The most common dermal reactions to tattoo pigments are granulomas and various lichenoid diseases. Other conditions noted have been cement dermatitis, collagen deposits, discoid lupus erythematosus, eczematous eruptions, hyperkeratosis and parakeratosis, and keloids.

Delayed reactions

Hypersensitive reactions to tattoos are known to lay latent for significant periods of time before exhibiting symptoms. Delayed abrupt chronic reactions, such as eczematous dermatitis, are known to manifest themselves from months to as many as twenty years after the patient received his or her most recent tattoo.

Azo-type pigments used in tattoos tend to cleave through enzymatic catalysis of redox reactions, resulting in highly electrophilic aromatic amine by-products capable of covalently binding with DNA. Napthol and Azos break down in sunlight exposure into toxic and/or carcinogenic aromatic amines. As with heavy metals, these by-products of the pigments' decomposition accumulate in the lymphatic system. Plastic-based inks (e.g., glow-in-the-dark ink) are known to lead to polymerisation under the skin, where the tattoo pigment particles converge into one solid plastic piece under the skin.Wikipedia:Disputed statement

Other adverse effects

Other documented conditions caused by tattoo pigments have been carcinoma, hyperplasia, tumours, and vasculitis. Keratoacanthoma may also occur, which makes excision of the affected area mandatory.

Haematoma

Occasionally, when a blood vessel is punctured during the tattooing procedure a haematoma (bruise) may appear. Bruises generally heal within one week. Bruises can appear as halos around a tattoo, or if blood pools, as one larger bruise.

Burden on lymphatic system

Some pigment migrates from a tattoo site to lymph nodes, where large particles may accumulate. When larger particles accumulate in the lymph nodes, inflammation may occur. Smaller particles, such as those created by laser tattoo treatments, are small enough to be carried away by the lymphatic system and not accumulate.

Interference with melanoma diagnosis

Lymph nodes may become discoloured and inflamed with the presence of tattoo pigments, but discoloration and inflammation are also visual indicators of melanoma; consequently, diagnosing melanoma in a patient with tattoos is made difficult, and special precautions must be taken to avoid misdiagnoses.

Case studies

Reactions to inks

- Mortimer NJ, Chave TA, Johnston GA (2003). "Red tattoo reactions". *Clin Exp Dermatol.* **28** (5): 508–10. PMID 12950341 [1].
- Lubeck G, Epstein E (1952). "Complications of tattooing". *Calif Med.* **76** (2): 83–5. PMID 14905289 [2].
- Engel E, Santarelli F, Vasold R, *et al.* (2008). "Modern tattoos cause high concentrations of hazardous pigments in skin". *Contact Dermatitis* **58** (4): 228–33. PMID 18353031 [3].
- Steinbrecher I, Hemmer W, Jarisch R (2004). "Adverse reaction to the azo dye Pigment Red 170 in a tattoo". *J Dtsch Dermatol Ges.* **2** (12): 1007–8. PMID 16285314 [4].
- Kleinerman R, Greenspan A, Hale EK (2007). "Mohs micrographic surgery for an unusual case of keratoacanthoma arising from a longstanding tattoo". *J Drugs Dermatol.* **6** (9): 931–2. PMID 17941365 [5].
- Pauluzzi P, Giordani M, Guarneri GF, *et al.* (1998). "Chronic eczematous reaction to red tattoo". *J Eur Acad Dermatol Venereol.* **11** (2): 187–8. PMID 9784053 [6].
- Kluger N, Minier-Thoumin C, Plantier F (2008). "Keratoacanthoma occurring within the red dye of a tattoo". *J Cutan Pathol.* **35** (5): 504–7. PMID 17976209 [7].
- Winkelmann RK, Harris RB (1979). "Lichenoid delayed hypersensitivity reactions in tattoos". *J Cutan Pathol.* **6** (1): 59–65. PMID 438395 [8].
- Verdich J (1981). "Granulomatous reaction in a red tattoo". *Acta Derm Venereol.* **61** (2): 176–7. PMID 6165203 [9].
- Cairns RJ, Calnan CD (1962). "Green tattoo reactions associated with cement dermatitis". *Br J Dermatol.* (74): 288–94. PMID 13875622 [10].
- Balfour E, Olhoffer I, Leffell D, *et al.* (2003). "Massive pseudoepitheliomatous hyperplasia: an unusual reaction to a tattoo". *Am J Dermatopathol.* **25** (4): 338–40. PMID 12876493 [11].
- Schwartz RA, Mathias CG, Miller CH, *et al.* (1987). "Granulomatous reaction to purple tattoo pigment". *Contact Dermatitis* **16** (4): 198–202. PMID 3595119 [12].
- Morales-Callaghan AM Jr, Aguilar-Bernier M Jr, Martínez-García G, *et al.* (2006). "Sarcoid granuloma on black tattoo". *J Am Acad Dermatol.* **55** (5 Suppl): S71-3. PMID 17052538 [13].

- Cui W, McGregor DH, Stark SP, *et al.* (2007). "Pseudoepitheliomatous hyperplasia - an unusual reaction following tattoo: report of a case and review of the literature". *Int J Dermatol.* **46** (7): 743–5. PMID 17614808 [14].

- Biro L, Klein WP (1967). "Unusual complications of mercurial (cinnabar) tattoo. Generalized eczematous eruption following laceration of a tattoo". *Arch Dermatol.* **96** (2): 165–7. PMID 6039153 [15].

- Antal AS, Hanneken S, Neumann NJ, *et al.* (2008). "Erhebliche zeitliche Variationsbreite von Komplikationen nach Tätowierungen". *Der Hautarzt* **59** (10): 769–71. PMID 18773181 [16].

Toxins in inks

- Civatte J, Bazex J (2007). "Piercing and tattooing: regulation is needed to reduce complications". *Bull Acad Natl Med.* **191** (9): 1819–38. PMID 18663977 [17].

- Hannuksela M (2005). "Tattoo pigments contains toxic compounds, but legislators do not pay attention". *Duodecim.* **121** (17): 1802-2. PMID 16262117 [18].

- Möhrenschlager M, Worret WI, Köhn FM (2006). "Tattoos and permanent make-up: background and complications". *MMW Fortschr Med.* **148** (41): 34–6. PMID 17190258 [19].

- Poon, Kelvin Weng Chun (2008), *In situ chemical analysis of tattooing inks and pigments: modern organic and traditional pigments in ancient mummified remains*, University of Western Australia

- Wollina U, Gruner M, Schönlebe J (2008). "Granulomatous tattoo reaction and erythema nodosum in a young woman: common cause or coincidence?". *J Cosmet Dermatol.* **7** (2): 84–8. PMID 18482009 [20].

Other dermatological reactions

- Kazandjieva J, Tsankov N (2007). "Tattoos: dermatological complications". *Clin Dermatol.* **25** (4): 375–82. PMID 17697920 [21].

- Müller KM, Schmitz I, Hupe-Nörenberg L (2002). "Reaction patterns to cutaneous particulate and ornamental tattoos". *Pathologe* **23** (1): 46–53. PMID 11974503 [22].

- Papageorgiou PP, Hongcharu W, Chu AC (1999). "Systemic sarcoidosis presenting with multiple tattoo granulomas and an extra-tattoo cutaneous granuloma". *J Eur Acad Dermatol Venereol.* **12** (1): 51–3. PMID 10188151 [23].

- Schmitz I, Müller KM (2004). "Elemental analysis of tattoo dyes: is there a potential risk from tattoo dyes?". *J Dtsch Dermatol Ges.* **2** (5): 350–3. PMID 16281523 [24].

MRI

- Klitscher D, Blum J, Kreitner KF, *et al.* (2005). "MRT-induced burns in tattooed patients: Case report of an traumatic surgery patient". *Unfallchirurg* **108** (5): 410–4. PMID 15909207 [25].

- Stecco A, Saponaro A, Carriero A (2007). "Patient safety issues in magnetic resonance imaging: state of the art". *Radiol Med.* **112** (4): 491–508. PMID 17563855 [26].

- Wagle WA, Smith M (2000). "Tattoo-induced skin burn during MR imaging". *AJR Am J Roentgenol* **174** (6): 1795. PMID 10845532 [27].

- Vahlensieck M (2000). "Tattoo-related cutaneous inflammation (burn grade I) in a mid-field MR scanner". *Eur Radiol.* **10** (1): 197. PMID 10663745 [28].

- Franiel T, Schmidt S, Klingebiel R (2006). "First-degree burns on MRI due to nonferrous tattoos". *AJR Am J Roentgenol* **187** (5): W556. PMID 17056894 [29].

- Kreidstein ML, Giguere D, Freiberg A (1997). "MRI interaction with tattoo pigments: case report, pathophysiology, and management". *Plast Reconstr Surg.* **99** (6): 1717–20. PMID 9145144 [30].

Lymph nodes and melanoma

- Gutermuth J, Hein R, Fend F, *et al.* (2007). "Cutaneous pseudolymphoma arising after tattoo placement". *J Eur Acad Dermatol Venereol.* **21** (4): 566–7. PMID 17374006 [31].

- Gall N, Bröcker EB, Becker JC (2007). "Particularities in managing melanoma patients with tattoos: case report and review of the literature". *J Dtsch Dermatol Ges.* **5** (12): 1120–1. PMID 17919304 [32].

- Chikkamuniyappa S, Sjuve-Scott R, Lancaster-Weiss K, *et al.* (2005). "Tattoo pigment in sentinel lymph nodes: a mimicker of metastatic malignant melanoma". *Dermatol Online J.* **11** (1): 14. PMID 15748555 [33].

- Hannah H, Falder S, Steele PR, *et al.* (2000). "Tattoo pigment masquerading as secondary malignant melanoma". *Br J Plast Surg.* **53** (4): 359. PMID 10876271 [34].</ref>

- Kluger N, Jolly M, Guillot B (2008). "Tattoo-induced vasculitis". *J Eur Acad Dermatol Venereol.* **22** (5): 643–4. PMID 18384545 [35].

- Sperry K (1992). "Tattoos and tattooing. Part II: Gross pathology, histopathology, medical complications, and applications". *Am J Forensic Med Pathol.* **13** (1): 7–17. PMID 1585890 [36].

- Zirkin HJ, Avinoach I, Edelwitz P (2001). "A tattoo and localized lymphadenopathy: a case report". *Cutis.* **67** (6): 471–2. PMID 11419018 [37].

Tattoo removal

Tattoo removal has been performed with various tools during the history of tattooing. While tattoos were once considered permanent, it is now possible to remove them with treatments, fully or partially. The expense and pain of removing tattoos will typically be greater than the expense and pain of applying them. Some jurisdictions will pay for the voluntary removal of gang tattoos.

Pre-laser tattoo removal methods include dermabrasion, salabrasion (scrubbing the skin with salt), cryosurgery, and excision which is sometimes still used along with skin grafts for larger tattoos. Tattoo removal by laser was performed with continuous-wave lasers initially, and later with Q-switched lasers, which became commercially available in the early 1990s. Today, "laser tattoo removal" usually refers to the non-invasive removal of tattoo pigments using Q-switched lasers. Typically, black and darker colored inks can be removed more completely.

Motivation for tattoo removal

In the United States, about 17% of people with tattoos experience some regret. According to a poll done in 2008, the most common reasons for regret are "too young when I got the tattoo (20%)," it's "permanent" and I'm "marked for life (19%)," and I just "don't like it (18%)." An earlier poll showed that 19% of British people with tattoos suffered regret, as did 11% of Italian people with tattoos. Surveys of tattoo removal patients were done in 1996 and 2006, and provided more insight. These patients typically obtained their tattoos in their late teens or early twenties, and just over half were women. About 10 years later, the patient's life had changed, and more than half of the patients reported that they "suffered embarrassment." A new job, problems with clothes, and a significant life event (wedding, divorce, baby) were also commonly cited as motivations.

Cover-up

Some wearers opt to cover an unwanted tattoo with a new tattoo. This is commonly known as a **cover-up.** An artfully done cover-up may render the old tattoo completely invisible, though this will depend largely on the size, style, colors and techniques used on the old tattoo. Covering up a previous tattoo necessitates darker tones in the new tattoo to effectively hide the older, unwanted piece.

Methods

Tattoo removal is most commonly performed using lasers that react with the ink in the tattoo, and break it down. The broken-down ink is then absorbed by the body, mimicking the natural fading that time or sun exposure would create. All Tattoo pigments have specific light absorption spectra. A tattoo laser must be capable of emitting adequate energy within the given absorption spectrum of the pigment in order to provide an effective treatment. Certain tattoo pigments, such as yellows, greens and

fluorescent inks are more challenging to treat than the darker blacks and blues. These pigments are more challenging to treat because they have absorption spectra that fall outside or on the edge of the emission spectra available in the respective tattoo removal laser.

Widely considered the gold standard treatment modality to remove a tattoo, laser tattoo removal requires repeat visits to remove tattoo. A brand of ink, InfinitInk, was developed to enable easier tattoo removal with a single laser treatment. The newer Q-switched lasers are said by the National Institutes of Health to result in scarring only rarely, however, and are usually used only after a topical anesthetic has been applied. Areas with thin skin will be more likely to scar than thicker-skinned areas. There are several types of Q-switched lasers, and each is effective at removing a different range of the color spectrum. Lasers developed after 2006 provide multiple wavelengths and can successfully treat a much broader range of tattoo pigments than previous Q-switched lasers.

Another type of tattoo removal is the manual, or machine method. This practice is very unpredictable and uses of a specialized type of gel, commonly mixed with saline, which is tattooed into the skin over the tattoo causing the ink in the dermis to bond with or be displaced by the gel and migrate to the surface of the epidermis. The incidence of scarring, tissue texture changes, keloids, prolonged healing, pain, discoloration (hyper- and hypopigmentation) and ink retention is extremely high with non-laser removal method and the person performing this treatment modality exposes him or herself to considerable liability. Methods like this are now only very rarely performed and in modern countries have been replaced by Q-switched laser treatment. Still other methods including thermal injury, dermabrasion and cryotherapy are also used but with the same unpredictable results and adverse side effects.

Mechanism of laser action

Experimental observations of the effects of short-pulsed lasers on tattoos were first reported in the late 1960s. In 1979 an argon laser was used for tattoo removal in 28 patients, with limited success. In 1978 a carbon dioxide was also used, but generally caused scarring after treatments It was not until the late 1980s that Q-switched lasers became commercially practical. One of the first published articles describing laser tattoo removal was authored by the group at Massachusetts General Hospital in 1990.

Tattoos consist of thousands of particles of tattoo pigment suspended in the skin. While normal human growth and healing processes will remove small foreign particles from the skin, tattoo pigment particles are permanent because they are too big to be removed. Laser treatment causes tattoo pigment particles to heat up and fragment into smaller pieces. These smaller pieces are then removed by normal body processes.

Laser tattoo removal is a successful application of the theory of selective photothermolysis (SPTL). For laser tattoo removal, SPTL for the selective destruction of tattoo pigments depends on four factors:

- The color of the light must penetrate sufficiently deep into the skin to reach the tattoo pigment.

- The color of the laser light must be more highly absorbed by the tattoo pigment than the surrounding skin. Different tattoo pigments therefore require different laser colors. For example, red light is highly absorbed by green tattoo pigments.
- The time duration (pulse duration) of the laser energy must be very short, so that the tattoo pigment is heated to fragmentation temperature before its heat can dissipate to the surrounding skin. Otherwise, heating of the surrounding tissue can cause burns or scars. For laser tattoo removal, this duration should be on the order of nanoseconds.
- Sufficient energy must be delivered during each laser pulse to heat the pigment to fragmentation. If the energy is too low, pigment will not fragment and no removal will take place.

Q-switched lasers are the only commercially available devices that can meet these requirements.

Laser parameters that affect results

Several colors of laser light (measured as wavelengths of laser energy) are used for tattoo removal, from visible light to near-infrared radiation. Different lasers are better for different tattoo colors. Consequently, multi-color tattoo removal almost always requires the use of two or more laser wavelengths. Tattoo removal lasers are usually identified by the lasing medium used to create the wavelength (measured in nanometers (nm)):

- Q-switched Frequency-doubled Nd:Yag: 532 nm. This laser creates a green light which is highly absorbed by red targets. Useful primarily for red tattoo pigments, this wavelength is also highly absorbed by melanin (the chemical which gives skin color or tan). This laser can produce side effects such as pigmentary changes (lightening or darkening of the skin).
- Q-switched Ruby: 694 nm. This laser creates a red light which is highly absorbed by green and dark tattoo pigments. Because it is more highly absorbed by melanin this laser may produce undesirable side effects such as pigmentary changes for patients of all but white skin.
- Q-switched Alexandrite: 755 nm. Similar to the Ruby laser, the alexandrite laser also creates a red light which is highly absorbed by green and dark tattoo pigments. However, the alexandrite laser color is much less absorbed by melanin, so this laser has a lower incidence of unwanted pigmentary changes.
- Q-switched Nd:YAG: 1064 nm. This laser creates a near-infrared light (invisible to humans) which is poorly absorbed by melanin, making this laser suitable for darker skin. Unfortunately, this laser wavelength is also poorly absorbed by all but the darkest tattoo pigments.
- Dye modules are available for some lasers to convert 532 nm to 650 nm light. Because this color conversion is optically inefficient, the resulting energy level may be weaker than desired for effective tattoo removal.

Pulsewidth or pulse duration is a critical laser parameter. All q-switched lasers have appropriate pulse durations for tattoo removal. However, lasers with a 5–10 nanosecond pulse duration are associated

with a higher incidence of acute punctate bleeding, compared to those with a 50–100 nanosecond duration.

Spot size, or the width of the laser beam, also affects treatment. Light is optically scattered in the skin, like automobile headlights in fog. Larger spot sizes slightly increase the effective penetration depth of the laser light, thus enabling more effective targeting of deeper tattoo pigments. Larger spot sizes also help make treatments faster.

Fluence or energy level is another important consideration. Fluence is measured in joules per square centimeter (J/cm²). Its important to get treated at high enough settings to fragment tattoo particles.

Repetition rate also help make treatments faster, but is not associated with any treatment effect.

Number of laser tattoo removal treatment sessions needed

Complete laser tattoo removal requires multiple treatment sessions, typically spaced at least 6 weeks apart. At each session, some but not all of the tattoo pigment particles are effectively fragmented, and the body removes the smallest fragments over the course of several weeks. The result is that the tattoo is lightened over time. Remaining large particles of tattoo pigment are then targeted at subsequent treatment sessions, causing further lightening. The number of sessions and spacing between treatments depends on various parameters, including the area of the body treated and skin color. Forearm and ankle tattoos generally take longest.

The amount of time required for the removal of a tattoo and the success of the removal varies with each individual. Factors influencing this include: skin type, location, color, amount of ink, scarring or tissue change, and layering. In the past health care providers would simply guess on the number of treatments a patient needed which was rather frustrating to patients. A predictive scale, the "Kirby-Desai Scale", was developed to assess the potential success and number of treatments necessary for laser tattoo removal, provided the medical practitioner is using a quality-switched Nd:YAG (neodymium-doped yttrium aluminum garnet) laser incorporating selective photothermolysis with 6 to 8 weeks between treatments.

The **Kirby-Desai Scale** assigns numerical values to six parameters: skin type, location, color, amount of ink, scarring or tissue change, and layering. Parameter scores are then added to yield a combined score that will show the estimated number of treatments needed for successful tattoo removal. It is recommended that this scale be used by all laser practioners to help determine the number of treatments required for tattoo removal and as a predictor of the success of the laser tattoo removal treatments.

Factors contributing to the success of laser tattoo removal

Multiple factors contribute to the success of laser tattoo removal one of which is a patient's own immune system. A healthy patient will get the best results. Adequate hydration, eight hours of sleep a night, maintaining a healthy weight, eating a well balanced diet, exercise, and non-smoking improve results. Treatment on some patients with immune systems problems are contraindicated.

Pain management during treatment

Laser tattoo removal can be quite painful. The pain is often described to be similar to that of hot oil on the skin, or a 'slap' from an elastic band; but when one considers the fact that a Q-switch laser can be fired around 10 pulses per second (by skilled laser-removal practitioners), the feeling of hot oil per pulse becomes moderately painful. So given the size and location of the tattoo, the process can be above the threshold of most people.[citation needed] Prescription strength topical anaesthetic creams or injections of anaesthetic solutions are usually used to manage pain, although some patients forgo any type of anaesthesia.

Depending on the patient's pain threshold, and while some patients may forgo anesthesia altogether, most patients will require some form of local anesthesia. Pre-treatment might include the application of an anesthetic cream under occlusion for 45 to 90 minutes prior to the laser treatment session. If complete anesthesia is desired, it can be administered locally by injections of 1% to 2% lidocaine with epinephrine.

Anecdotal reports have noted that patients receiving anesthesia by local injection will require additional treatments as the injection causes mechanical edema, spreading out the tattoo ink, which in turn makes it more difficult for the laser light to act on specific ink particles. It has been reported that infiltration of local anesthesia will add an additional treatment or two.

Post-treatment considerations

Immediately after laser treatment, a slightly elevated, white discoloration with or without the presence of punctuate bleeding is often observed. This white color change is thought to be the result of rapid, heat-formed steam or gas, causing dermal and epidermal vacuolization. Pinpoint bleeding represents vascular injury from photoacoustic waves created by the laser's interaction with tattoo pigment. Minimal edema and erythema of adjacent normal skin usually resolve within 24 hours. Subsequently, a crust appears over the entire tattoo, which sloughs off at approximately 14 days post treatment. As noted above, some tattoo pigment may be found within this crust. Post-operative wound care consists of topically applied antibiotic ointment and a non-occlusive dressing. Fading of the tattoo will be noted over the next 6 to 8 weeks and re-treatment energy levels can be tailored depending on the clinical response observed.

Side effects and complications

About half of the patients treated with Q-switched lasers for tattoo removal will show some transient changes in the normal skin pigmentation. These changes usually resolve in 6 to 12 months but may rarely be permanent.

Hyperpigmentation is related to the patient's skin tone, with skin types IV,V and VI more prone regardless of the wavelength used. Twice daily treatment with hydroquinones and broad-spectrum sunscreens usually resolves the hyperpigmentation within a few months, although, in some patients, resolution can be prolonged.

Transient textural changes are occasionally noted but often resolve within a few months, however, permanent textural changes and scarring very rarely occur. If a patient is prone to pigmentary or textural changes, longer treatment intervals are recommended. Additionally, if a patient forms a blister or crust post treatment, it is imperative that they do not manipulate this secondary skin change. Early removal of a blister of crust increases the chances of developing a scar. Additionally, patients with a history of hypertrophic or keloidal scarring need to be warned of their increased risk of scarring.

Local allergic responses to many tattoo pigments have been reported, and allergic reactions to tattoo pigment after Q-switched laser treatment are also possible. Rarely, when yellow cadmium sulfideis used to "brighten" the red or yellow portion of a tattoo, a photoallergic reaction may occur. The reaction is also common with red ink, which may contain cinnabar (mercuric sulphide). Erythema, pruritus, and even inflamed nodules, verrucose papules, or granulomas may present. The reaction will be confined to the site of the red/yellow ink. Treatment consists of strict sunlight avoidance, sunscreen, interlesional steroid injections, or in some cases, surgical removal. Unlike the destructive modalities described, Q-switched lasers mobilize the ink and may generate a systemic allergic response. Oral antihistamines and anti-inflammatory steroids have been used to treat allergic reactions to tattoo ink.

Studies of various tattoo pigments have shown that a number of pigments (most containing iron oxide or titanium dioxide) change color when irradiated with Q-switched laser energy. Some tattoo colors including flesh tones, light red, white, peach and light brown containing pigments as well as some green and blue tattoo pigments, changed to black when irradiated with Q-switched laser pulses. The resulting gray-black color may require more treatments to remove. If tattoo darkening does occur, after 8 weeks the newly darkened tattoo can be treated as if it were black pigment.

Very rarely, Q-switched laser treatment can rupture blood vessels and aerosolizes tissue requiring a plastic shield or a cone device to protect the laser operator from tissue and blood contact. Protective eye-wear may be worn if the laser operator choose to do so.

With the mechanical or salabrasion method of tattoo removal, the incidence of scarring, pigmentary alteration (hyper- and hypopigmentation),and ink retention are extremely high.

The use of Q-switched lasers could very rarely produce the development of large bulla. However, if patients follow post care directions to elevate, rest, and apply intermittent icing, it should minimize the

chances of bulla and other adverse effects. In addition, health care practitioners should contemplate the use of a cooling device during the tattoo removal procedure. While the infrequent bulla development is a possible side effect of Q-switched laser tattoo removal, if treated appropriately and quickly by the health care practitioner, it is unlikely that long term consequences would ensue.

Risks

While generally accepted as a safe treatment and the gold standard method to remove a tattoo, complications of laser tattoo removal include the possibility of discoloration of the skin such as hypopigmentation (white spots, more common in darker skin) and hyperpigmentation (dark spots) as well as textural changes. Very rarely, burns may result in scarring. Rarely, "paradoxical darkening" of a tattoo may occur, when a treated tattoo becomes darker instead of lighter. This seems to occur more often with flesh tones, pink, and cosmetic make-up tattoos. .

Some of the pigments used (especially Yellow #7) are known to break down into toxic chemicals in the body when attacked by light. This is especially a concern if these tattoos are exposed to UV light or laser removal; the resulting degradation products end up migrating to the kidneys and liver. Laser removal of traumatic tattoos may similarly be complicated depending on the substance of the pigmenting material. In one reported instance, the use of a laser resulted in the ignition of embedded particles of firework debris.

Further reading

- Verhaeghe, Evelien (January 2010). "Chapter 7: Techniques and Devices Used for Tattoo Removal". In De Cuyper, Christa; Pérez-Cotapos S, Maria Luisa. *Dermatologic Complications with Body Art*. Heidelberg: Springer-Verlag. pp. 91–105. doi:10.1007/978-3-642-03292-9_7 [1]. ISBN 9783642032912.
- Goldberg, David J. (4 December 2007). "Chapter 3: Pigmented Lesions, Tattoos, and Disorders of Hypopigmentation". *Laser Dermatology: Pearls and Problems*. Malden, Massachusetts: Blackwell. pp. 71–113. doi:10.1002/9780470691991.ch3 [2]. ISBN 9781405134200.
- William Kirby, Francisca Kartono, Alpesh Desai, Ravneet R. Kaur, Tejas Desai, David Geffen, *Treatment of Large Bulla Formation after Tattoo Removal with a Q-Switched Laser*,Journal of Clinical and Aesthetic Dermatology, January,2010 http://www.jcadonline.com/2210/ treatment-of-large-bulla-formation-after-tattoo-removal-with-a-q-switched-laser/#more-2210

External links

- The Kirby-Desai Scale: A Proposed Scale to Assess Tattoo-removal Treatments [3]
- General Tattoo Removal Information [4]

Article Sources and Contributors

Tattoo *Source*: http://en.wikipedia.org/?oldid=390448074 *Contributors*: Tbhotch

History of tattooing *Source*: http://en.wikipedia.org/?oldid=388862597 *Contributors*: Fæ

Body modification *Source*: http://en.wikipedia.org/?oldid=386914514 *Contributors*: Plarroy

Body piercing *Source*: http://en.wikipedia.org/?oldid=389992788 *Contributors*: Hmains

Tattoo artist *Source*: http://en.wikipedia.org/?oldid=387542400 *Contributors*: 1 anonymous edits

Tattoo machine *Source*: http://en.wikipedia.org/?oldid=388778123 *Contributors*:

Tattoo ink *Source*: http://en.wikipedia.org/?oldid=388557431 *Contributors*: 1 anonymous edits

Tattoo studio *Source*: http://en.wikipedia.org/?oldid=384140025 *Contributors*: SuperHamster

Body art *Source*: http://en.wikipedia.org/?oldid=385732221 *Contributors*: 1 anonymous edits

Permanent makeup *Source*: http://en.wikipedia.org/?oldid=390546447 *Contributors*:

Medical tattoo *Source*: http://en.wikipedia.org/?oldid=371137448 *Contributors*:

Temporary tattoo *Source*: http://en.wikipedia.org/?oldid=390378532 *Contributors*: 1 anonymous edits

Teardrop tattoo *Source*: http://en.wikipedia.org/?oldid=390174032 *Contributors*:

Criminal tattoo *Source*: http://en.wikipedia.org/?oldid=390574402 *Contributors*: 1 anonymous edits

Body suit (tattoo) *Source*: http://en.wikipedia.org/?oldid=320976019 *Contributors*: Welsh

Christian tattooing in Bosnia and Herzegovina *Source*: http://en.wikipedia.org/?oldid=377329831 *Contributors*: Yopie

Lucky Diamond Rich *Source*: http://en.wikipedia.org/?oldid=383912578 *Contributors*: 1 anonymous edits

LA Ink *Source*: http://en.wikipedia.org/?oldid=390621159 *Contributors*: 1 anonymous edits

Kat Von D *Source*: http://en.wikipedia.org/?oldid=390608000 *Contributors*: Nymf

Miami Ink *Source*: http://en.wikipedia.org/?oldid=389025927 *Contributors*: Diannaa

Ami James *Source*: http://en.wikipedia.org/?oldid=389026306 *Contributors*: NotAnonymous0

London Ink *Source*: http://en.wikipedia.org/?oldid=387556759 *Contributors*: 1 anonymous edits

Inked *Source*: http://en.wikipedia.org/?oldid=345543986 *Contributors*: Funandtrvl

Inked (magazine) *Source*: http://en.wikipedia.org/?oldid=390150428 *Contributors*: 1 anonymous edits

Lyle Tuttle *Source*: http://en.wikipedia.org/?oldid=387102069 *Contributors*:

List of tattoo artists *Source*: http://en.wikipedia.org/?oldid=383031834 *Contributors*: Belovedfreak

Tattoo medical issues *Source*: http://en.wikipedia.org/?oldid=374661182 *Contributors*:

Tattoo removal *Source*: http://en.wikipedia.org/?oldid=386676980 *Contributors*: 1 anonymous edits

Image Sources, Licenses and Contributors